IMAGES
of America

MEXICANS IN
PHOENIX

Gloria
Thank you for all
your service for our city

Frank
Barrios

ON THE COVER: Around 1915, Mexican families enjoy a leisurely afternoon picnic along the Salt River in Phoenix. Featured in this photograph are Martin Gold, who is the tall man in the back row wearing the black hat, and his wife, Dolores, who is standing in front of him. Their youngest daughter Dolores (Lolita) is the little girl wearing the large bow, and to her right in a white dress is Concha de la Lama, the daughter of Pedro de la Lama. To the left of Martin's wife, Dolores, is her sister Petronia (Pelona), and in front of her with dark hair parted in the middle is Martin's daughter Helen Gold. In the back row, wearing a dark dress (not holding glass) is another daughter, Rose Gold. (Courtesy author.)

IMAGES
of America

MEXICANS IN PHOENIX

Frank M. Barrios

Arizona Historical Foundation

ARCADIA
PUBLISHING

Published by Arcadia Publishing
Charleston SC, Chicago IL, Portsmouth NH, San Francisco CA

Printed in the United States of America

Library of Congress Catalog Card Number: 2007934173

For all general information contact Arcadia Publishing at:
Telephone 843-853-2070
Fax 843-853-0044
E-mail sales@arcadiapublishing.com
For customer service and orders:
Toll-Free 1-888-313-2665

Visit us on the Internet at www.arcadiapublishing.com

To the Mexican American people of Phoenix—a people whose contributions were important but whose legacy was lost to history

CONTENTS

ACKNOWLEDGMENTS

Unless otherwise indicated by a credit beneath each photograph, the images appearing in this book now reside in my personal collection, which would not have been collected without the generous donations of others over the years. I wish to thank all of the following who have helped preserve the history that I now share here: Tom, Art, and Esther Killeen for the Gold family collection; Katie Macias; the Adam Diaz family; the Calderon family; Tillie Moreno; Arsenia Torres; Paul Hobaica; George Metsopolos; Julian Reveles; Mary Walker Camarena; Mary Lorona; Lynn and Richard Andrade; Ray Gano; Humberto Preciado; Rudy Domenzain; William Canalez; Phoenix Museum of History; Burton Barr Central Library; Phoenix Memorial Hospital; Catholic Diocese of Phoenix Archives; Arizona State Historical Society; Yuma Historical Society; American Legion Tony Soza/Ray Martinez Thunderbird Post 41; Franciscan Friars of the Province of Santa Barbara; and Claretian Missionaries of the U.S. Western Province in Los Angeles.

Special thanks to Arcadia Publishing and especially to Jared Jackson for all of the assistance he provided.

INTRODUCTION

Although there was no founding event, most historians place Phoenix's beginnings in the year 1868, when it is theorized that a group of people began moving into the Phoenix area to farm and provide services to Fort McDowell, which was founded in 1865. Jack Swilling and Y. T. Smith are prominent names of those individuals who began to colonize Phoenix in 1868. Swilling's wife, Trinidad Escalante Swilling, was a Mexican and the first non–Native American woman to move to the Phoenix area. No doubt many other unknown Mexican individuals were part of the 1868 colonization of the area that would become the community of Phoenix.

As Phoenix prospered and word got out about the new community, immigrants, Civil War veterans, Mexican citizens, and Mexican Americans came to Phoenix looking for opportunities to make a living. The newcomers included laborers and respected businessmen, such as Jesus Otero, Miguel Peralta, and Jose Redondo. The most famous of these immigrants was Enrique Garfias, a young Mexican American who came to Phoenix in 1870 and quickly acquired a reputation as a capable lawman. He was elected to three terms as Phoenix constable and five terms as Phoenix marshal.

In 1887, train service to Phoenix was completed, and this made it easier for large numbers of non-Hispanic immigrants to move to Phoenix. Although the armed conflicts and social unrest of Mexico caused large numbers of Mexicans to move out of Mexico and into Phoenix, the Mexican population of Phoenix continued to decrease as a percentage of the total population. In 1870, fifty-two percent of the population of Phoenix was Hispanic, and by 1900, the population had dropped to 14 percent of the total.

The majority religion of the Mexican American Community of Phoenix has remained Catholic throughout its history. In 1881, the Mexican American Community built the first Catholic church in Phoenix and called it St. Mary's; it was a small adobe building on Monroe Street between Third and Fourth Streets. In 1896, Franciscan priests, noting that there were only 15 English-speaking families in the parish, took over the Catholic community and built a new church, which was finally completed in 1915. By 1906, the number of English-speaking families had increased to 143.

The beginning of the 20th century brought with it continuing social unrest and marginalization of the Mexican American community. In 1914, Pedro de la Lama and several of his friends started La Liga Protectora Latina in an effort to protect Mexican civil rights and to address issues of English-only restrictions and limitations on hiring of Mexican workers. In 1915, Fr. Novatus Benzing announced that Spanish-language Masses would be in the cellar and that English-language Masses would be in the main church. It caused a huge uproar that eventually led to the building of a Mexican American Catholic church called Immaculate Heart of Mary, which was completed in 1928 only a few blocks from the St. Mary's Catholic Church on East Monroe. Over the years, individual Catholic priests worked closely with the Mexican American community, and their influence had a huge impact on the development of the community. Catholic priests were assigned to specific churches to provide for the spiritual needs of the parish community. But often they would become involved in the social and political issues of their times. A few of the

more prominent priests who served the needs of the Mexican American community include Fr. Antimo Nebreda, the priest who built Immaculate Heart of Mary; Fr. Albert Braun, the priest who built Sacred Heart Church in the Golden Gate barrio; Fr. Emmett McCloughlin, the priest who built St. Monica's Catholic Church (today it is Pius X); and Fr. Jose Hurtado, who was born in Gilbert, Arizona, was known as a civil rights activist, and was assigned to Immaculate Heart of Mary.

In the early years of Phoenix development, prominent Mexican Americans had homes in central Phoenix, while larger communities of Mexican Americans were found living in certain neighborhood areas. As time went on, Mexican American communities were concentrated in barrio areas located south of Van Buren Street, although many middle-class, mostly bilingual families were able to break out of the barrio areas and move into racially mixed areas located north of Van Buren Street. However, most Mexican Americans, especially the Spanish-speaking and poor families, quickly found that they were not welcome and chose to stay in the barrio areas south of Van Buren Street. The barrio areas of Phoenix had names such as Golden Gate, Cuattro Milpas, Grant Park, and El Campito. Mexican American families grew up in these areas and took pride in being a part of their community. The location of schools and churches added to the sense of belonging.

Music and entertainment are also a major part of the Mexican American story of Phoenix and could be called the soul of the community. Spanish-language radio, movies, music, and dancing were all provided to the community. Some of this entertainment was from Mexico, but a large amount of it came from local Mexican American talent, including bandleaders Pete Bugarin, Chelo Acevedo, and Chapito Chavaria; singers Molly Cota and Tencha Leon; and entertainment personalities Leonard Calderon, Carlos Morales, and Hector Ledesma. Local Phoenix theaters, like the Ramona, the Rex, and the Azteca, provided the Mexican American community the type of entertainment they wanted to see.

Much of the Mexican American workforce of Phoenix was traditionally associated with labor jobs and agriculture. However, many individuals owned their own businesses and provided services to their community. Spanish-language or bilingual businesses were popular in the community and offered services not provided by the English-speaking businesses of Phoenix. Chinese and European immigrants often made a living selling exclusively to the Spanish-language barrios of Phoenix. Because the Mexican American community did not have political representation until 1953, prominent business owners, such as Vincent Canalez, Leonard Calderon, and Gabriel Peralta, also became community leaders.

Although Phoenix was not the largest city in Arizona, they had the most Spanish-language newspapers of any city in the state. In the early years, *El Progresso* was published by Jose Redondo and his famous brother-in-law Enrique Garfias; *El Mensajero* was published by Jesus Melendrez, cofounder of La Liga Protectora Latina; and *El Sol* was published by Jesus and Josefina Franco, who are also credited with bringing Las Fiestas Patrias to Phoenix.

The death of Enrique Garfias in 1896 ended the political leadership of the Mexican community until 1953. However, leadership continued through various organizations such as La Liga Protectora Latina, Sociedad Zaragoza, La Alianza Hispano Americana, the Latin American Club, and the League of United Latin American Citizens (LULAC). It was always prominent businessmen who provided leadership to the community either through organizations or directly through personal involvement. Vincent Canalez and Luis Cordova were political and brought back the prospects of political involvement. The Mexican Chamber of Commerce was made up of the most prominent businessmen of Phoenix and worked hard for social change. Significant changes came from American Legion Post 41 under the leadership of Pipa Fuentes and Ray Martinez. In one of the most significant chapters of the Mexican American story came the election of Adam Diaz, who became the first Mexican American to be elected to the Phoenix City Council in 1953. Since that time, there have been many Mexican American leaders who have filled elected positions. In 1975, Arizonans elected Raul Castro to be Arizona's first Mexican American governor, and today there are two Mexican American congressmen, Edward Pastor and Raul Grihalva.

One

THE EARLY DAYS

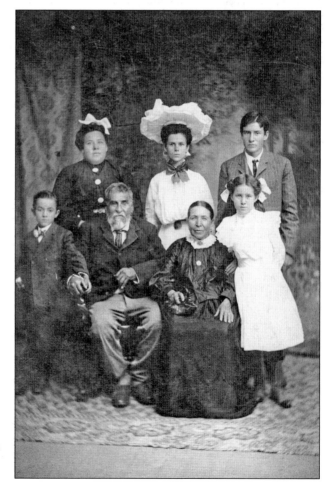

Jesus Martinez and his wife, Rosa Rivas Martinez, their daughter Petronia (upper left, standing), and their grandchildren were photographed in Phoenix about 1905. Jesus and Rosa roamed much of southern Arizona and California when it was part of Mexico. In the late 1800s, Jesus was operating a stage stop between San Diego and Phoenix. His oldest son, Octaviano Martinez, was killed by Apaches in the early 1880s. Jesus and Rosa finally settled in Phoenix in the early 1900s. They both died in 1906, three months apart.

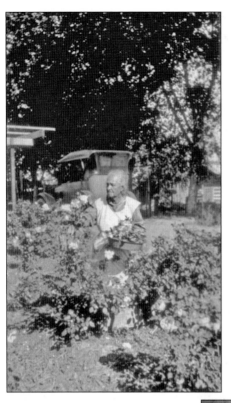

Just prior to her death in 1925, Trinidad Escalante Swilling is seen working in her garden at her home. Trinidad was born in Hermosillo, Sonora, and married Jack Swilling in Tucson, Arizona, in 1864. She came to Phoenix in 1868 and is considered to be the first non–Native American woman resident of Phoenix. She had seven children with Jack and after his death married Henry Shumaker and had three more children. Her first husband, Jack, was considered one of the founders of Phoenix. (Courtesy Phoenix Museum of History.)

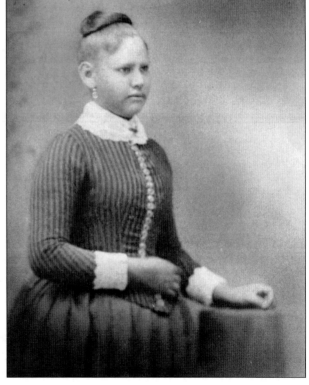

Concepcion Woolsey was the daughter of King Woolsey and his Yaqui mistress, Lucy Martinez. King Woolsey was one of Arizona's first state legislators; he represented the Phoenix area and was famous for his battles with the Apaches. King Woolsey never considered Concepcion his legal daughter or heir to his property. He had three children with Lucy, two girls and a boy. Nuns in Yuma raised Concepcion and her sister Clara, and both married Hispanic men and moved to the Phoenix area. The only living ancestors of King Woolsey are living in Phoenix as part of the Phoenix Hispanic community. (Courtesy Clara De La Cruz.)

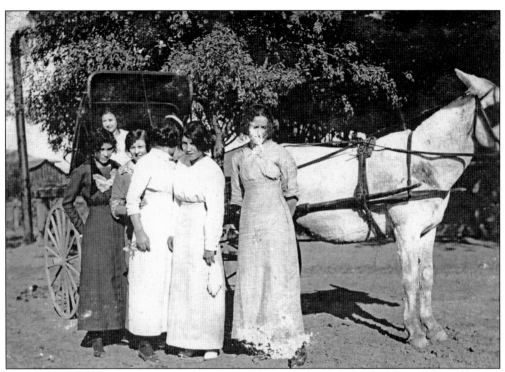

Just as today, there are both wealthy and poor communities in Phoenix. Within the Hispanic community of early Phoenix, both lived side by side. In the upper photograph, a group of young ladies inspects a classy buggy, wanting to know who was visiting. In the lower photograph, a poor family of Mexican immigrants lives in tents. Both photographs were taken a short distance from each other.

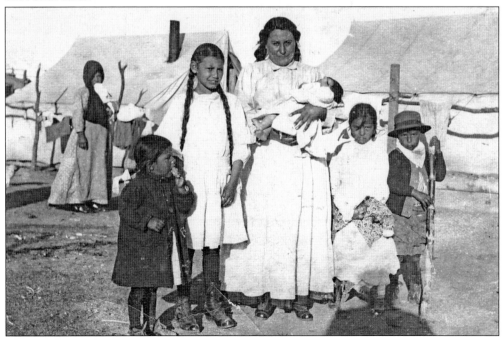

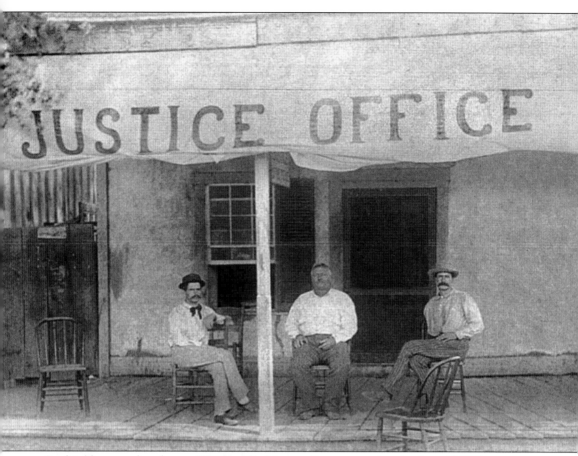

In this photograph, taken at 200 East Washington Street sometime in the mid-1880s, are town marshal Enrique Garfias (left) and deputy town marshals Hiram C. McDonald (center) and Billy Blankenship. Enrique Garfias was the first politically elected Hispanic official in Phoenix history. He was elected to three terms as constable and five terms as town marshal. He was a legendary lawman whose action-packed career was regularly publicized in the local newspapers. He was very popular in both the Hispanic and non-Hispanic communities and was the last publicly elected Hispanic in Phoenix government until the election of Adam Diaz in 1953. Enrique arrived in Phoenix in 1874 and in 1896 had a freak accident where his horse fell on him. He died several months later from complications. (Courtesy Phoenix Police Museum.)

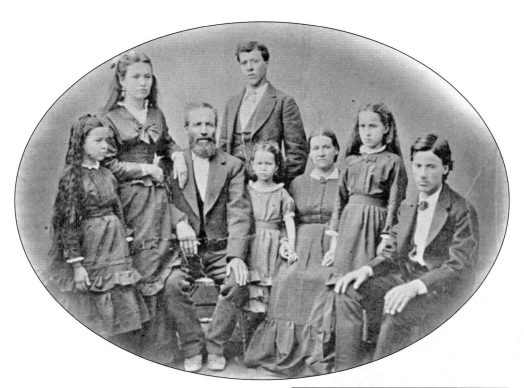

Jose Maria Redondo, his wife, Piedad, and their six children posed for this family photograph in Yuma sometime in the 1870s. Jose Maria was one of the most prominent Hispanic leaders in Arizona and was elected state legislator representing the Yuma area until his death in 1878. It is interesting to note that three of his six children were living in Phoenix prior to 1900. His oldest daughter, Luz (second from the left), was married to David Baltz, a prominent cattleman and large landowner in Phoenix. The Baltz School District was named for the Baltz family. Elena (second from the right) married Enrique Garfias, the Phoenix town marshal, and Jose Luis (on the right) began publishing the Spanish-language Phoenix newspaper *El Progresso* in 1883. (Courtesy Yuma Historical Society.)

Elena Redondo married Phoenix's most famous town marshal, Enrique Garfias, in Yuma in 1883. One year later, she gave birth to a daughter Maria, and in 1887, a son Emmanuel was born. On March 27, 1890, she died from complications following childbirth and is buried in Loosley City Cemetery, located at Fifteenth Avenue and Jefferson Street. (Courtesy Yuma Historical Society.)

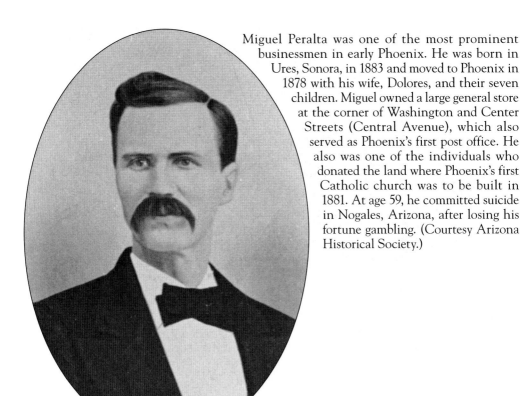

Miguel Peralta was one of the most prominent businessmen in early Phoenix. He was born in Ures, Sonora, in 1883 and moved to Phoenix in 1878 with his wife, Dolores, and their seven children. Miguel owned a large general store at the corner of Washington and Center Streets (Central Avenue), which also served as Phoenix's first post office. He also was one of the individuals who donated the land where Phoenix's first Catholic church was to be built in 1881. At age 59, he committed suicide in Nogales, Arizona, after losing his fortune gambling. (Courtesy Arizona Historical Society.)

Margarita Trujillo, holding the umbrella, is accompanied by her niece Natalia Torres. Natalia's parents, Francisco and Cleotilde Torres, had a home at 1127 West Jefferson Street where the family ran an informal restaurant and provided seamstress services. Francisco was employed at the Phoenix Flour Mill located at Ninth and Jackson Streets. (Courtesy Tillie Moreno.)

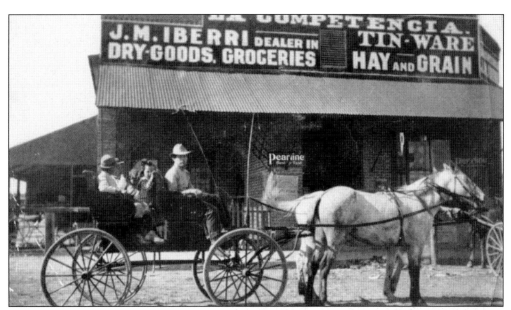

La Competencia was a merchandise store located at Sixth and Jackson Streets and was one of the many businesses owned by Jose Iberri. Driving the double-seated buckboard is Charlie Iberri, with several of his brothers and sisters riding in the back seats. (Courtesy Loretta Taber.)

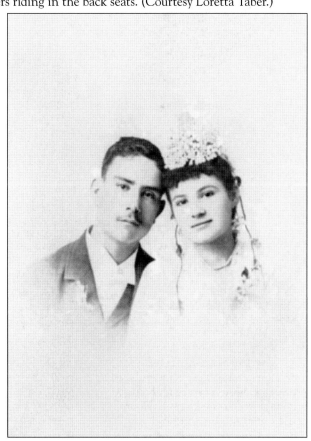

Featured are Jose Monteverde Iberri and his wife, Juanita Baine Iberri, at their wedding ceremony. Jose was born in Guaymas, Sonora, and came to Phoenix in the early 1890s. In 1894, he married 15-year-old Yuma-born Juanita Baine; her father was Irish and her mother was Mexican. This couple had 19 children. She died in 1961. Iberri was a wealthy businessman who owned several stores, a cattle operation east of Mesa, and large parcels of land in what is today South Phoenix. (Courtesy Loretta Taber.)

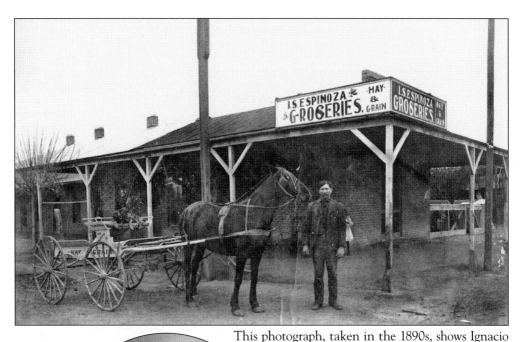

This photograph, taken in the 1890s, shows Ignacio Espinosa standing outside his grocery store at the corner of Second and Jackson Streets. Ignacio and his wife, Concepcion Lopez, were both from Sonora and immigrated to Phoenix in its earliest years. As time went on, the store was converted into the bar La Amapola. In 1976, Ernesto Miranda was stabbed to death there in a dispute over a card game. Miranda was the rapist whose appeal led to the U.S. Supreme Court's decision that any person in police custody must be told he has the right to remain silent and to consult an attorney. (Courtesy Romo family and Phoenix Museum of History.)

Ignacio Espinosa was also one of the founding members of La Liga Protectora Latina, an early civil rights organization created to protect Mexican immigrant rights in Arizona. (Courtesy Romo family and Phoenix Museum of History.)

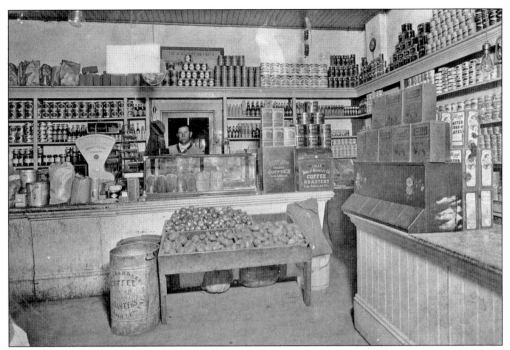

This photograph was taken inside the Espinosa store. Ignacio Espinosa is standing behind the counter waiting to serve his next customer. No doubt the layout was typical of early stores of Phoenix in the 1890s. (Both courtesy Romo family and Phoenix Museum of History.)

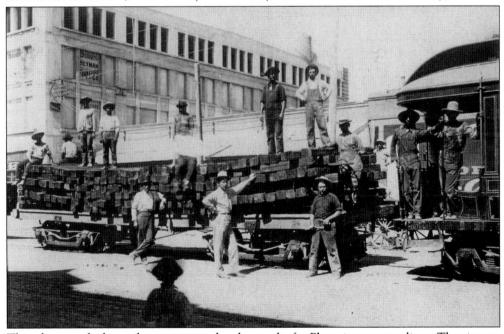

This photograph shows the process used to lay tracks for Phoenix streetcar lines. The sign on the building on the left reads "Doris-Heyman Furniture Co." and places the tracks in downtown Phoenix. The man with the arrow above him is Estevan Chavez and is shown as one of the many Mexican American workmen laying the tracks. (Courtesy Mike Robles).

This photograph was taken during the 1891 Salt River Flood looking south from the Jefferson Building. In the center of the photograph is the H. W. Ryder Lumber Company, located on the south side of City Hall Plaza at 113 East Jefferson Street. The 1891 flood was one of the largest Salt River floods ever recorded, and most of the downtown Phoenix area south of Jefferson Street was inundated. As a result, many residents moved their homes north of Jefferson Street, and the area south of Jefferson Street became devalued with large numbers of minorities moving into this area. By the 1900s, the area had a large Mexican American population. (Courtesy Burton Barr Central Library.)

Two

COMMUNITY LIFE

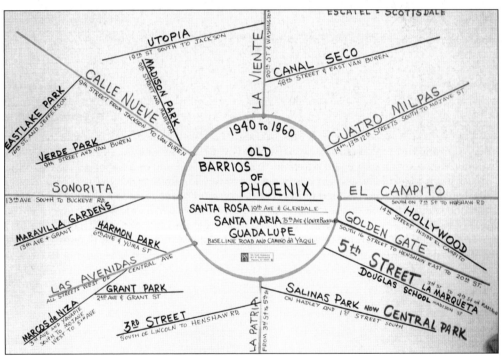

Minority groups, such as African Americans, Chinese, and Mexican Americans, often lived in certain concentrated areas because it was the only place they were allowed to live or it was where they felt safe and secure among their own people. Mexican Americans created subgroups within their larger minority area and identified each subgroup with a folk name. People who lived within these areas strongly identified with the area name and took considerable pride in being part of that community. Today many Phoenix residential areas are given district names names such as Willo, Coronado, and Encanto, so it was with the Mexican American residential areas identified by their historical community names. Local resident Rudy Domenzain drew a map identifying all the various barrio designations used in Phoenix. (Courtesy Rudy Domenzain.)

One of the early more prominent Mexican American areas was located south of Washington Street from about Central to Seventh Street. In the early 1900s, this area had considerable commercial and residential structures and was home to many middle-class to wealthy Mexican Americans. The photograph was taken looking northwest near Fourth and Jackson Streets. The house covered in trees is the home of Martin Gold, who was the man that Gold Alley was named for. Gold was as Austrian who married Dolores Martinez and became a part of the Mexican American community that surrounded him. He was a businessman, realtor, and provider of custom harvesting for surrounding farms. Also shown in the photograph is one of his horse-drawn chuck wagons used to feed the men during crop harvesting. In the background is the Westward Ho hotel, as this photograph was probably taken sometime in the mid-1930s, soon after construction of the hotel. By the 1930s, the residential area was declining and becoming primarily commercial; it would later be known as La Marketa, a reference to the many produce centers found throughout the area.

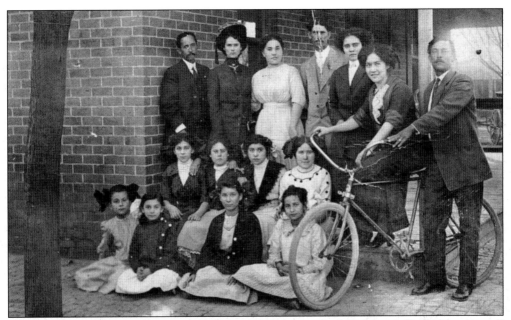

A group of prominent Mexican Americans poses on the porch of the Martin Gold home, located at 229 South Fourth Street at the intersection of Fourth Street and Gold Alley. The little girl in the first row at the far left is Maime Espinosa, adopted daughter of Ignazio Espinosa, and the little girl in the second row at the far right is Helen Gold, daughter of Martin Gold. (Courtesy Romo family and Phoenix Museum of History.)

Gold Alley ran east and west from Seventh Street to near Central Avenue and was between Jackson Street on the south and Madison Street on the north. The photograph was taken looking east at the intersection of Fourth Street and Gold Alley. The men are parading their horses in front of the Gold Home. The man at the far left on horseback waiting for his turn to display his riding skills is Pedro Martinez, brother of Dolores (Martinez) Gold, Martin Gold's wife.

It is believed that these photographs were taken in the Gold Alley area. Written in the back of one of the photographs is the following statement, "Young Mexican and his trainer Jorge Pope of San Diego, Calf. Vicenti L. Hernandez."

This photograph was taken at the back of the Espinosa Store at Second and Jackson Streets. Espinosa's home was in the same building as the store, in the eastern portion facing Jackson Street. Ignacio is the man in the middle enjoying a leisurely evening with friends outside his home. (Courtesy Romo family and Phoenix Museum of History.)

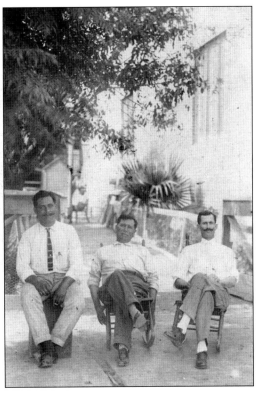

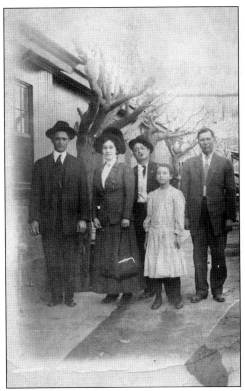

A group of people are seen here entering the Espinosa home on Jackson Street. Ignacio and his adopted daughter Maime are on the left. (Courtesy Romo family and Phoenix Museum of History.)

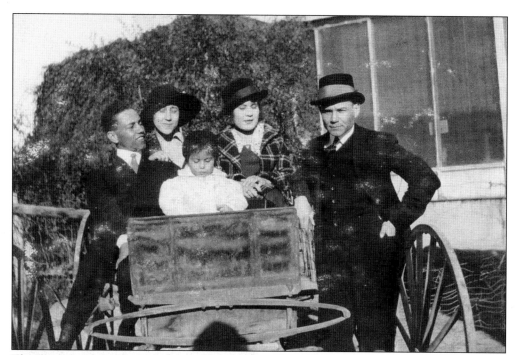

The Iberri family is pictured on top of an old horse-drawn buggy about 1914, at a time when the automobile was in common use. No doubt many old buggies were in backyards no longer in use. Family members decided to pose in one of these deteriorating buggies.

A group of young people pose in front of a home in the Gold Alley area.

Helen Lopez (left) and a friend are pictured near a tree; the homes shown in the background of these types of images are often substandard, but the individuals posing for photographs are always well-dressed and presentable.

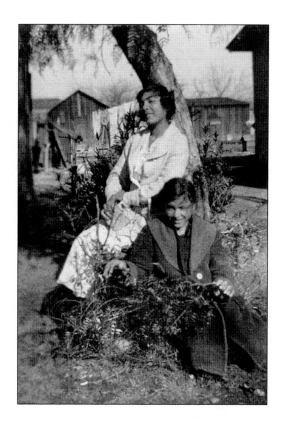

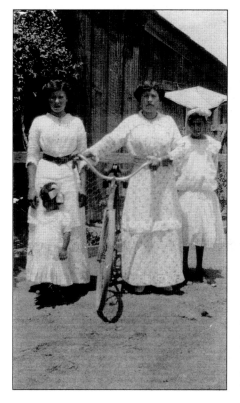

This photograph was taken in the vicinity of Eleventh and Madison Streets around 1910. The lady holding the bicycle is Escepula Chavez. No doubt riding a bicycle while wearing a long dress would have been difficult. (Courtesy Mike Robles).

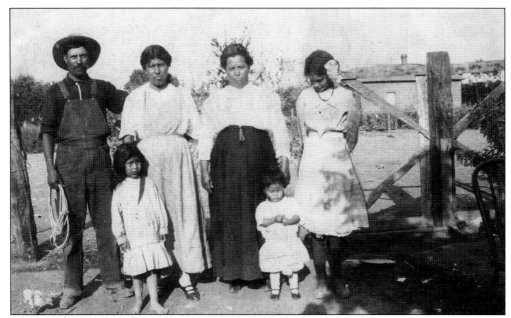

This photograph was taken near Eleventh and Madison Streets about 1910. The man on the left wearing the overalls is Hilario Chavez, and the woman standing next to him is his wife, Escepula. The names of the other people in the photograph are unknown. (Courtesy Mike Robles.)

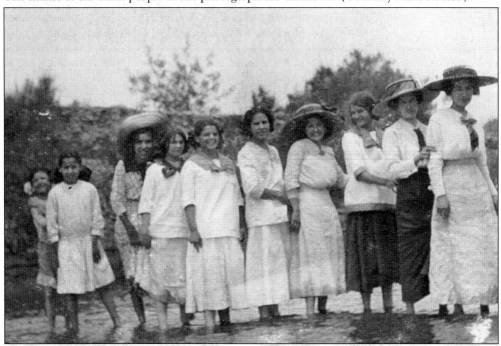

The Salt River flows through the city of Phoenix. The area south of the river is generally referred to as South Phoenix. Most of the city lies north of the river. The ladies pictured here were from the vicinity of Gold Alley, an area located about one mile north of the river, and they had come to wade in the river to cool off. In 1915, when this photograph was taken, the Salt River was running year-round.

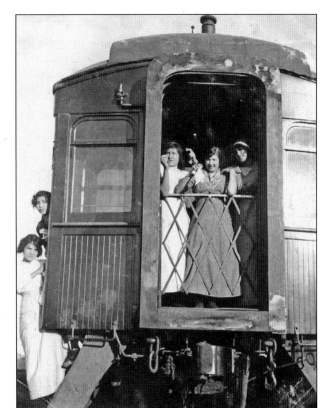

In 1914, just as today, the railroad tracks paralleled Jackson Street, and railroad cars and railroad equipment was left on railroad siding throughout the area. Helen Gold and her girlfriends would play on the equipment and pose for photographs.

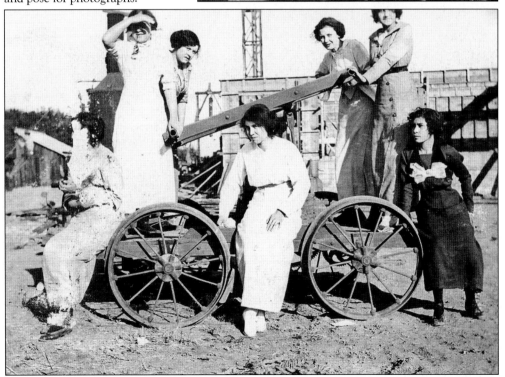

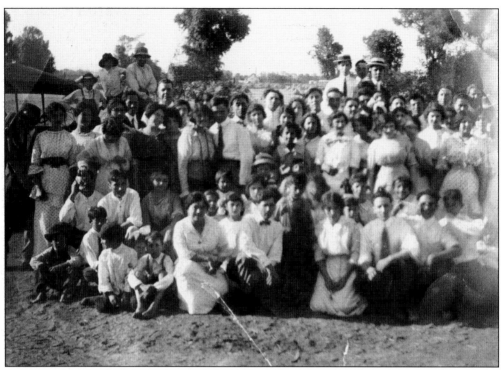

At a time when family entertainment was limited, rural picnics were a favorite among the Mexican community of Phoenix. The trees and harvested fields in the background places this particular party in a field.

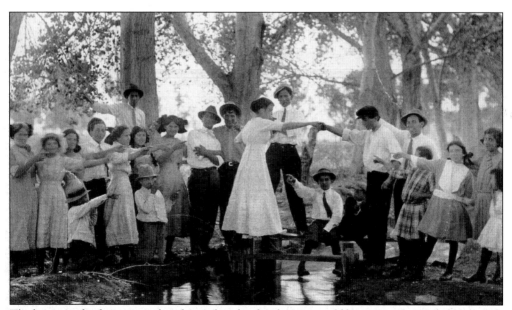

The large stands of cottonwoods indicate that this family party could be near a river, probably the Salt River. Everyone is posing for this photograph with a small ditch in the middle of the picture.

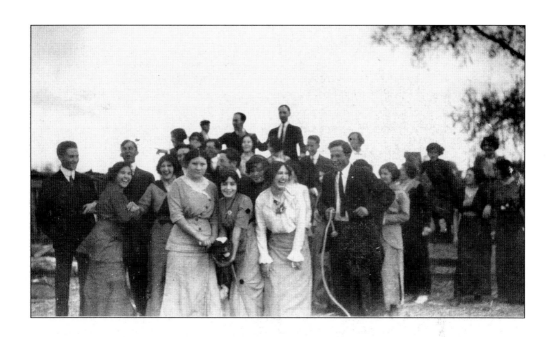

This appears to be a party of young adults that probably occurred at a nearby ranch or dairy. Both photographs show very tame cows being played with by the revelers. It should be noted that early Phoenix was not a large city, and ranches could be reached a short distance from Phoenix.

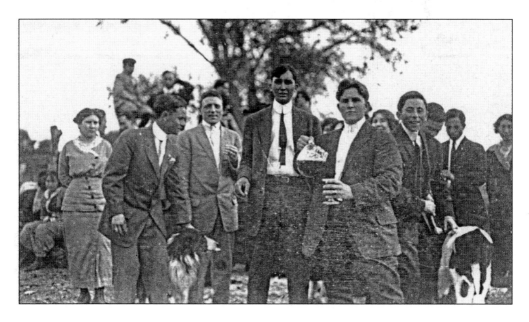

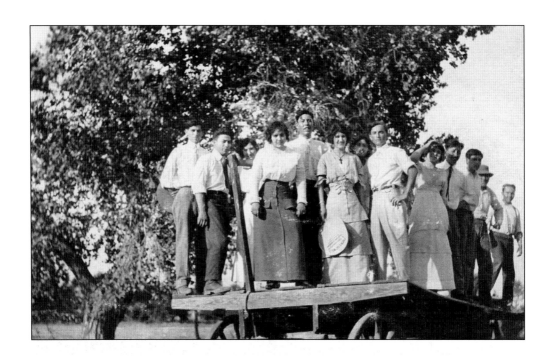

Traditional hayrides were not just found in the Midwest and East. The Phoenix Mexican community also had their version of a hayride. So many of the photographs were staged for the photographer, it is not certain if these young people just got onto the wagon for a photograph or if the wagons were horse-drawn and actually went somewhere.

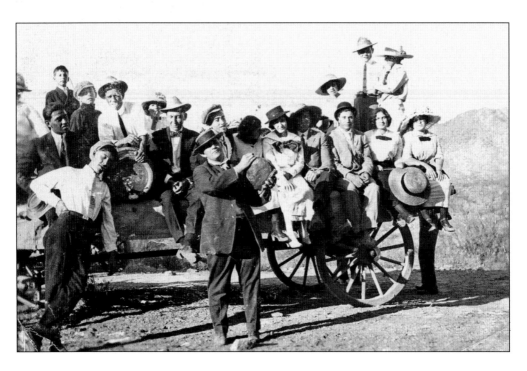

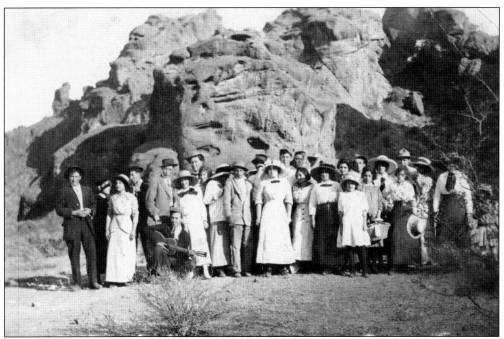

A favorite party place for all groups in Phoenix was Echo Canyon at Camelback Mountain. In 1915, when these photographs were taken, there were likely no problems finding a picnic area. In the background the Praying Monk rock structure can be seen clearly. In almost 100 years, the Praying Monk has not changed. Unfortunately, the same cannot be said of the area, as expensive homes now surround it.

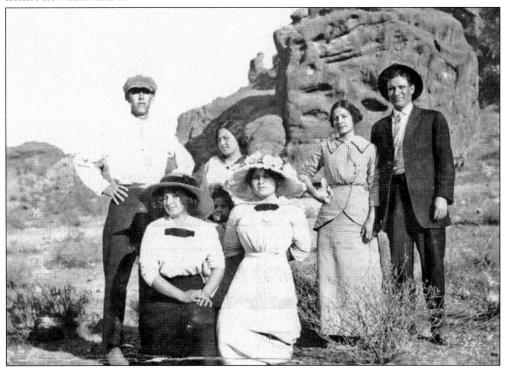

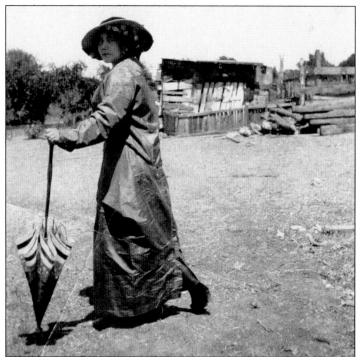

A well-dressed lady is seen here on the move. The background shows the poverty of the area, but this lady is dressed nicely—complete with a matching umbrella—for some special event.

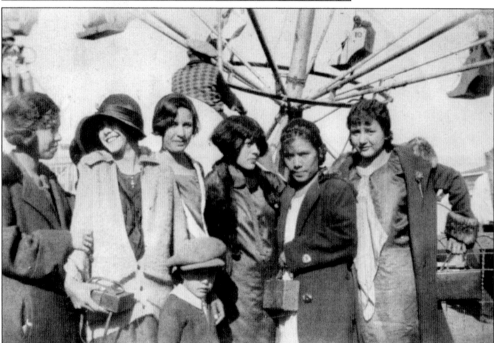

It is assumed that this photograph was taken on a Saturday or Sunday, and that these young ladies did not ditch school to attend the state fair and the accompanying carnival. In this 1925 photograph is Theodora Gastelum, standing on the far right, and next to her is Maclovia Fernandez. They remained life-long friends, living next door to each other in the Grant Park barrio. (Courtesy Julian Reveles.)

This photograph was taken near Eleventh and Madison Streets about 1910. The man with the guitar lived in the area and was from Mexico. He was known only as "Campeche." The name of the little girl in the photograph is unknown. (Courtesy Mike Robles.)

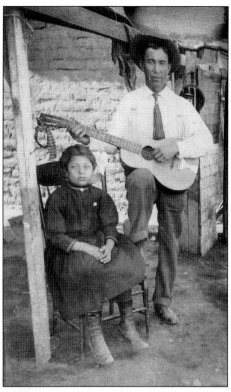

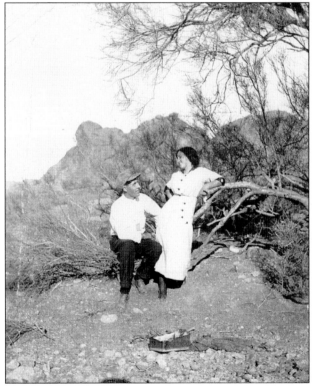

This photograph was taken near Forty-eighth Street and Camelback Road near Camelback Mountain. Today this area is a combination of businesses and expensive homes, but in 1915, it was a remote area where a young couple could get away and enjoy the solitude of the desert.

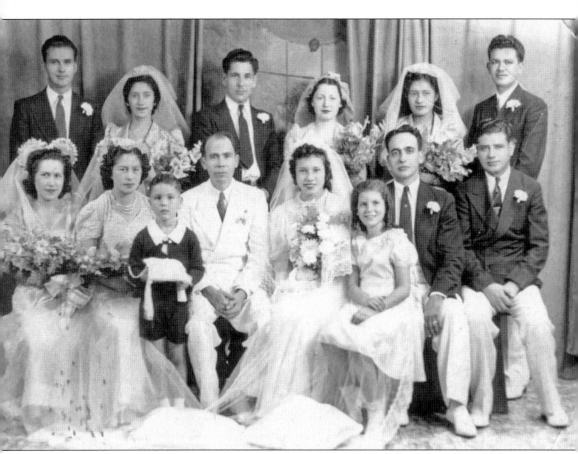

The Mexican community always celebrated weddings with solemnity followed with a huge fiesta and party. Shown is the wedding party at the wedding of Pete Bugarin, a local musician with his own orchestra who became very popular with the Mexican community in Phoenix. Seated second from the right is Carlos Morales, one of the most popular Spanish-language radio announcers at KOY. (Courtesy Mary Walker Camarena.)

In 1919, Louis Killeen married Helen Gold. Louis's father was from Ireland, and his mother from Uris, Sonora. Louis Killeen was born in Mexico. Helen Gold's father was Martin Gold from Austria, and her mother was Dolores Martinez from Arizona. Both families were prominent in the Mexican community, and the Phoenix *Mensajero* newspaper called the wedding the social event of the year. In the second row, from left to right, are Oscar Perez; his wife to be, Concha de la Lama; Ralph Gaxiola, who became the first Spanish-language radio announcer for KOY; and Helen's sister Rose Gold.

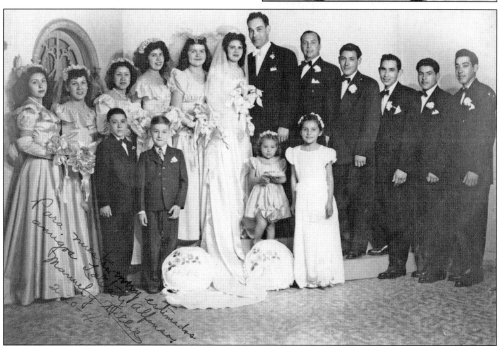

This 1949 photograph of the wedding party at the wedding of Manolito Salcido was taken inside St. Anthony's Catholic Church, located at 909 South First Avenue. The church was built in 1948 in a heavily Mexican American area of Phoenix, and this wedding was one of the church's first.

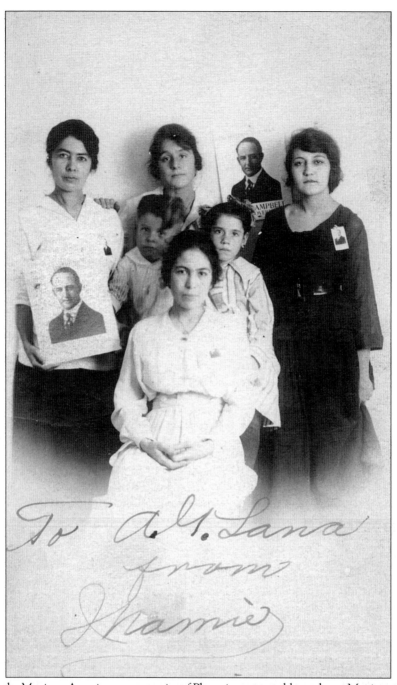

Although the Mexican American community of Phoenix was not able to elect a Mexican American to political office until 1953 with the election of Adam Diaz as city councilman, the community was political and did support many non-Hispanic candidates. This image shows a group of Mexican American women and their children holding election posters for Thomas Campbell, who was running for governor. In 1917, Campbell served for a short time as governor but was removed in the same year as a result of a disputed election. He ran again for governor, was elected, and served from 1919 to 1923. (Courtesy Romo family and Phoenix Museum of History.)

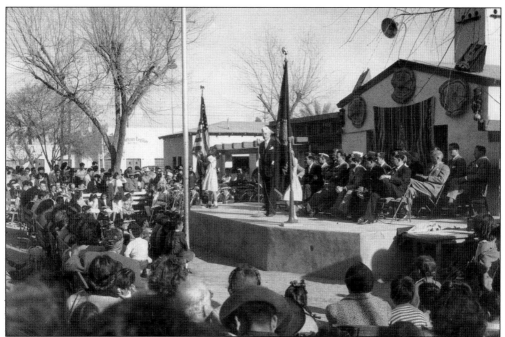

After World War II, many Mexican American soldiers returned to Phoenix and joined together to create the Mexican American Legion Thunderbird Post 41. This photograph was taken in March 1948 at Grant Park during the dedication of the new post building located at 715 South Second Avenue. Post 41 was organized in October 1945 with a membership of 16. It was immediately chartered and quickly began growing. It became a center for political activism and began pushing for civil rights. Barry Goldwater and Fr. Albert Braun were both non-Hispanic members of Post 41. The post was later named Tony Soza Post 41. The lower photograph shows how the facility looks today. (Both courtesy American Legion Post 41.)

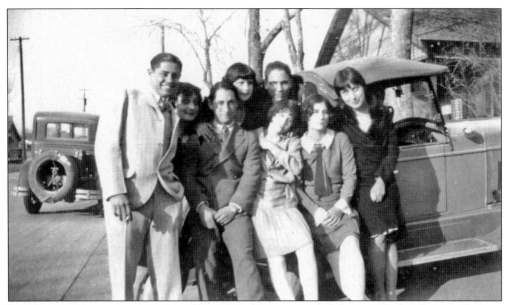

Just as in every generation and in all cultures, parents and adults are always concerned about youth. Above, a group of young people is hanging out in the barrio. This photograph was taken during the Roaring Twenties. Below, another group of young people are also hanging out, but this time it is the 1950s, and the location is the Calderon Ballroom. The quiet young man in dark clothes on the right is Nano Calderon, son of Leonard Calderon, the owner of the ballroom. (Below courtesy Calderon family.)

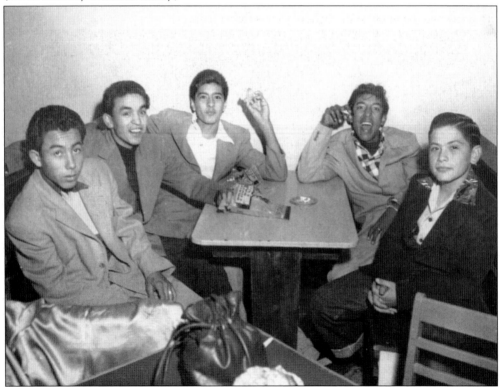

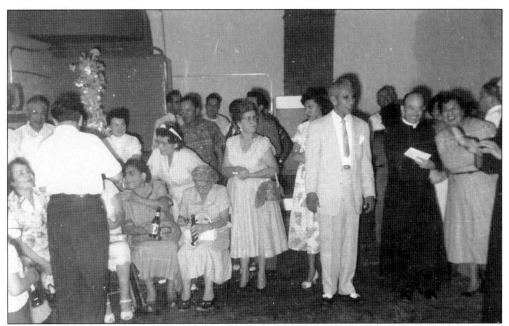

A church social, *c.* 1950, was held on the grounds of St. Anthony's Catholic Church, located at 909 South First Avenue. Dressed in white is Adam Diaz, who, in 1953, became the first Mexican American elected to the Phoenix City Council. Also pictured are Maria Garcia, seated at the far left and wearing a white patterned dress, and directly above her and wearing glasses is Sal Balderas. The first visible woman seated to the right of Garcia is Magdalena Vanderford (holding the beer), and the priest to the right of Diaz is Father Sanz.

Pictured is the oldest remaining part of the earlier Friendly House buildings. Friendly House was started in 1921 by Susan Green under an Americanization theme. It later became an agency dedicated to helping Mexican Americans and other new immigrants in Phoenix. Adam Diaz and Placida Garcia Smith were two of the more prominent leaders who helped to energize this agency and are often given credit for its great successes.

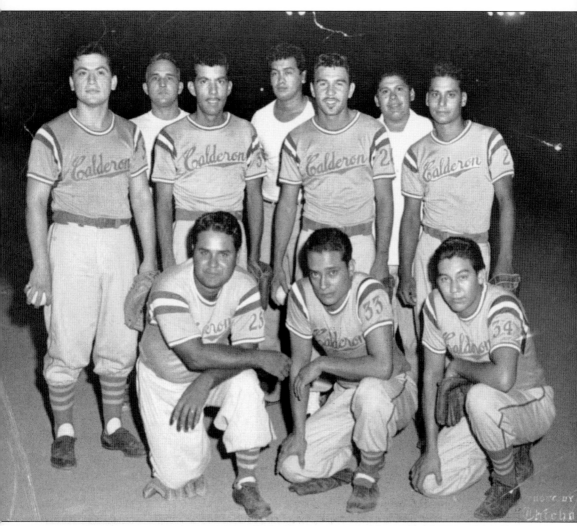

Leonard Calderon, owner of Calderon Ballroom, was public spirited and involved in many community activities. This photograph shows the local Mexican American baseball team he sponsored. On the far left is Leonard's son Nano, and, in the back row standing second from the right is Junior Verdugo, one of the owners of Oaxaca's Mexican Restaurant in downtown Phoenix. (Courtesy Calderon family.)

Three

THE CHILDREN

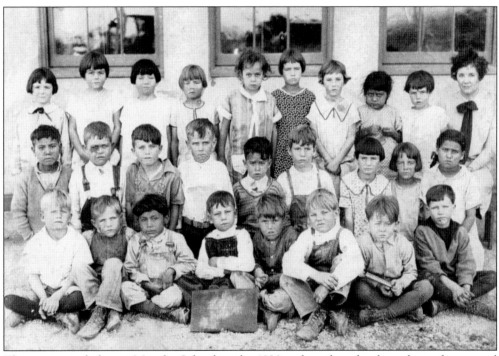

This is a typical class at Murphy School in the 1920s, when the school was located in a rural area. In the early years, Phoenix schools were open to all students except for black children, who were forced to attend all-black schools. Many school photographs show Mexican American, Chinese, Native American, and Anglo children all posing together. Other class photographs show predominantly Mexican Americans schoolchildren simply because there were large numbers of Mexican Americans living in that school district. In some parts of Arizona, Mexican American children were forced to attend segregated schools, but this was not the case in Phoenix.

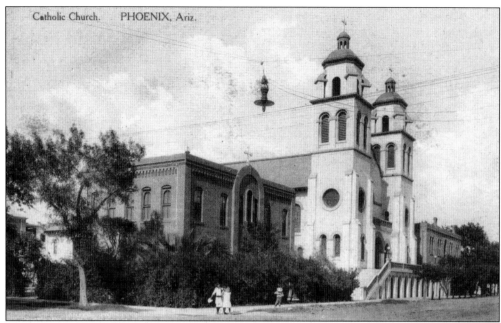

In the early years, the Franciscan Fathers at St. Mary's built two schools, one on each side of the church. The school built to the west was called St. Anthony's (La Escuela de San Antonio) and was for children who could not speak English. There was no cost associated with attending this school. The other school, St. Mary's Grammar School, which was located to the east of the church, was available to everyone who could speak English, and there was a cost associated with attending. The upper photograph shows La Escuela de San Antonio, and the lower photograph shows children attending the English-speaking school. It should be noted that the schools were segregated according to language and not race. In the lower photograph, there are several Mexican American children and one Chinese girl attending the English-speaking school. (Above courtesy Burton Barr Central Library.)

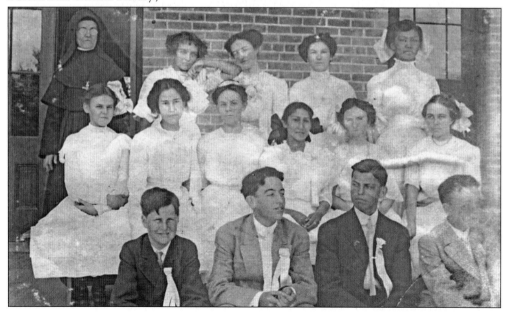

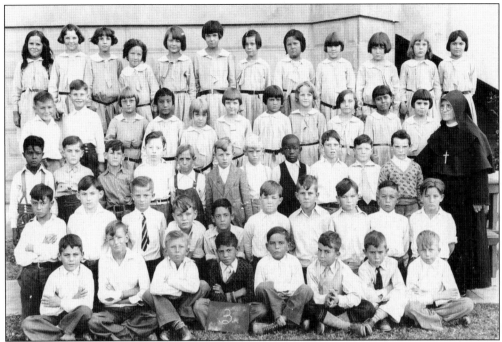

In later years, the Franciscan Fathers of St. Mary's dropped the two-school concept, and all children were taught in one grammar school. In the 1950s, the church pastor attempted to send all Spanish surname children to the Catholic school at Immaculate Heart, which was primarily Mexican American. However, this attempt was quickly rejected, and the grammar school remained open to students of all races. When Phoenix's public school policy forced black children to attend all-black schools, St. Mary's accepted black children whose parents wished to send their children to there. These two photographs were taken of St. Mary's Grammar School students in the 1930s.

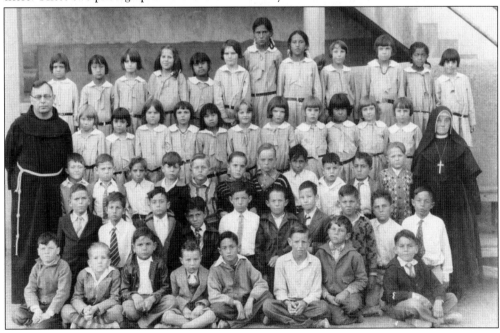

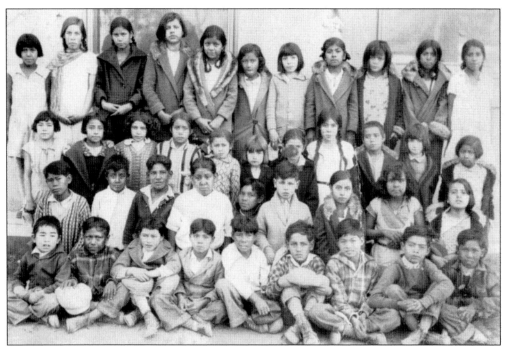

Two public school classes at two different schools in early Phoenix are pictured. Above, an almost all Mexican American class of children is shown, while the lower photograph shows a mixed group of children. In general, in rural farm areas where Mexican farm labor was concentrated, the schools were heavily Mexican American. In the central Phoenix area, however, there would be fewer Mexican American children, except in the Mexican barrio areas. (Above courtesy Mary Walker Camarena.)

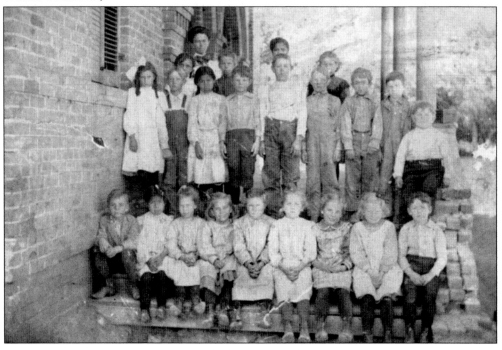

Mexican American children attended Grant School. The boy in the middle with his hand on his hip is Julian Reveles. In the 1960s and 1970s, Julian hosted his own Phoenix television and radio shows. Although, he is now semi-retired, he is often asked to be the master of ceremonies for local events. (Courtesy Julian Reveles.)

Seen here around 1905, in the Gold Alley, is Maime Espinosa (second from left), the adopted daughter of Ignacio and Concepcion Espinosa. Maime would later marry Peter Romo and have four children. Peter ran the Romo Meat Market, near the Ramona Theater on East Washington Street. (Courtesy Romo family and Phoenix Museum of History.)

These children were born to Mexican American families of early Phoenix—Dave Martinez (left) in 1896 and Angelito Ochoa (below) in 1917. Dave Martinez was the son of Pedro Martinez; his mother died in childbirth. Dave was raised in the Gold Alley area by Pedro's two sisters, Petronia Martinez and Dolores (Martinez) Gold. (Below courtesy Katie Macias.)

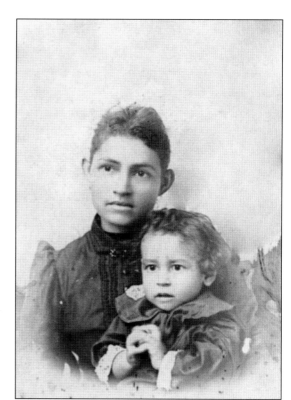

Two proud Phoenix mothers are pictured with their babies. Pictured at right is Antonina Killeen with her daughter Maria, and below is Maria Pacheco and her baby boy Ramoncito. Maria Killeen grew up in Phoenix, married Jim Hodges, and moved to Yuma, where she spent the remainder of her life.

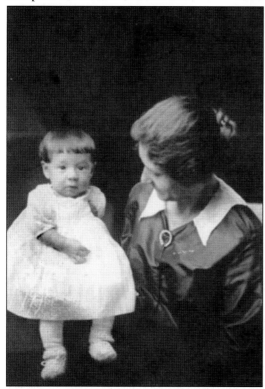

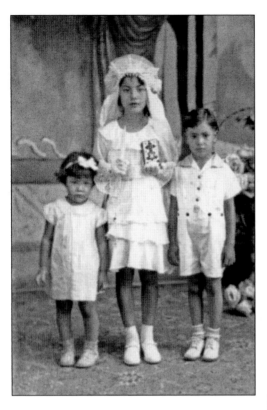

A large number of Mexican Americans in Phoenix were Catholic, and two Catholic events that were particularly important to them were baptism and first Holy Communion. These significant events were marked with great celebration. These two young girls have just received their first communion, an event that required a special photograph for remembrance. For modern Mexican girls, the event of special significance is the Quinceniera, a religious celebration when the girl turns 15. (Left courtesy Katie Macias.)

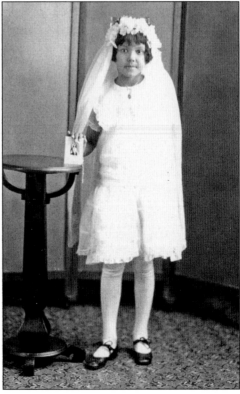

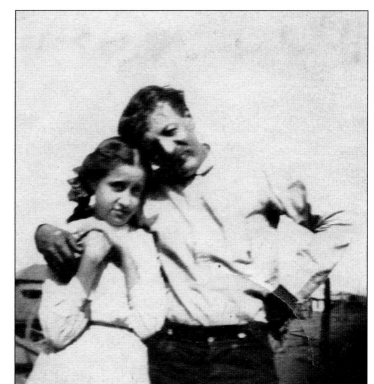

Rose and Dolores Gold were the two daughters of Martin and Dolores Gold. Shown at right is Rose Gold with her uncle Pedro Martinez, and below is Dolores Gold (Lolita) standing on top of an early horse-drawn carriage. All childhood photographs of Lolita show her with a large bow in her hair.

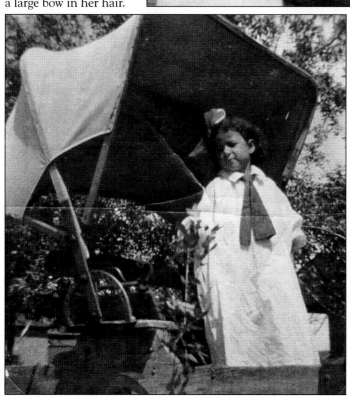

Martin Gold owned a custom harvesting business that required hiring of many laborers. No doubt many of his workmen were recruited from Gold Alley. The work required camping out in rural areas where the fields were being harvested. In all probability, many of the workman's families followed the men to their work place, and, as in all cultures, the children found ways to enjoy themselves. These two c. 1914 photographs show Mexican American children in various stages of play.

Gilbert Cruz grew up in Central Phoenix and went to Wilson School. He became a schoolteacher and taught in the central Phoenix area. He was the last principal of Grant School before it was closed. Gilbert's father was born in Mexico and published the Phoenix Spanish-language newspaper *El Valedor.* (Courtesy Gilbert Cruz.)

Here are Leonard Calderon's first wife, Vera, and the couple's two children Armida and Nano. Nano became a business partner with Leonard and opened his own lounge called Nano's, which was connected to the Calderon Ballroom.

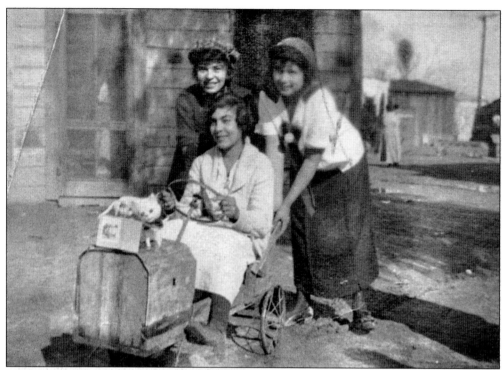

Helen Lopez sits on top of a child's pushcart being propelled by two of her girlfriends. In 1914, when this photograph was taken, very few Mexican American families could afford to purchase toys for their children. No doubt someone's father built this cart.

A young Hispanic girl posed for this photograph around 1915. Note her long braids and her loose-fitting blouse, both of which were styles of the time.

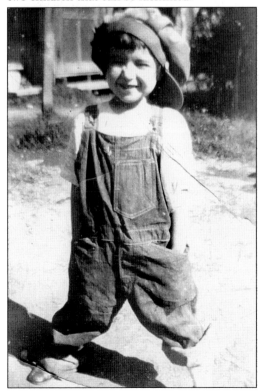

These photographs might be considered the Mexican American version of *Our Gang*. Every barrio and neighborhood had its combination of kids. In the Mexican American barrios, each kid would have a nickname. In the photograph at right, taken in the 1920s, Louis Killeen (second row, second from left) and Chacho Caudillo (third row, far right) are the only two children that can be identified.

Sophia Deleon, who was living in Phoenix, had a visit from relatives from Tucson. In this photograph, Sophia is standing in the back and is surrounded by all her family.

Maria Sanchez holds a young Katie Valenzuela after a 1929 baptism at St. Mary's Catholic Church in Phoenix. Katie grew up in Phoenix and got married there. (Courtesy Katie Macias.)

Four

THE CATHOLIC CHURCH AND THE MEXICAN PEOPLE

Immaculate Heart of Mary Catholic Church, located at 909 East Washington Street, was completed in 1928 to serve the needs of the Mexican community of Phoenix. The need for a separate Catholic church began in 1915 with the completion of St. Mary's Catholic Church, located at 400 East Monroe Street. The pastor, Fr. Novatus Benzig, declared that all the Spanish Masses would be in the basement church, while all the English Masses would be in the main facility of the new church. This decision sparked a huge controversy between Father Benzing and the Mexican community. The Mexican community of Phoenix banned together to create the Mexican Catholic Society and took their concerns to Bishop Henry Granjon in Tucson. The bishop gave them permission to start their own Catholic church and donated $500 toward construction. Immaculate Heart of Mary was built only a few blocks away from St. Mary's Basilica. (Courtesy Catholic Diocese of Phoenix Archives)

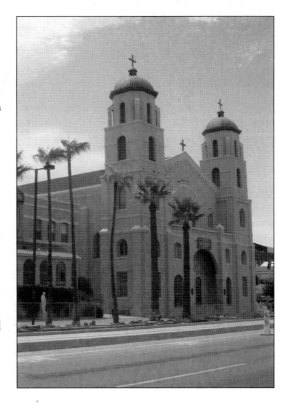

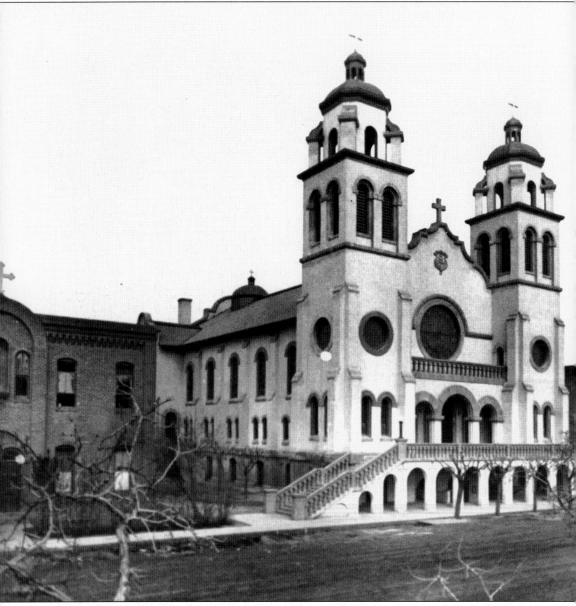

The photograph was taken soon after the completion of the new St. Mary's Catholic Church in 1915. The main entrance to the church is clearly visible on the elevated area in the center, accessible by stairways on either side. The entrance to the basement church was on the ground level immediately below the main entrance. Although the masses were segregated according to language and not race, the obvious symbolism of giving the Spanish-speaking people an inferior facility was clearly not acceptable to the Mexican American community of Phoenix. (Courtesy of the Phoenix Museum of History.)

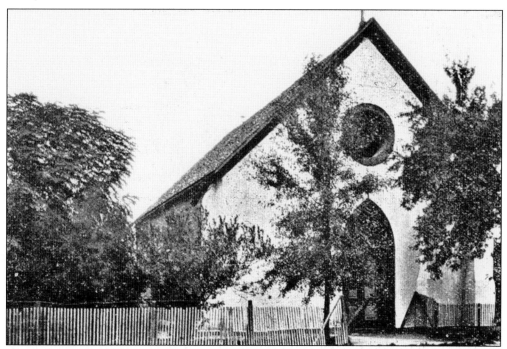

The first Catholic church in Phoenix was completed in 1881 by Fr. Edward Gerard on the site where St. Mary's Basilica stands today. It was built of adobe, cost about $5,000, and stood until it was demolished in 1903. The land for the church was donated by Mexican businessmen, and the church was built by Mexican labor. In 1896, the Franciscans took over the parish and the church, noting that there were only 15 English-speaking families attending the church. (Courtesy Catholic Diocese of Phoenix Archives.)

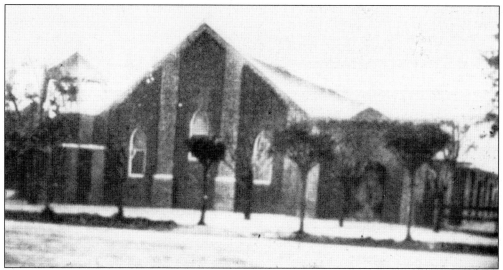

After demolishing the adobe church in 1903, the Franciscans immediately began planning for a larger church. In the interim, they built a basement church. The plan was to cover the basement area with a temporary building that would function as a church facility until they had the money to complete the larger church. The larger church was finally completed in 1915 and today is St. Mary's Basilica. (Courtesy Catholic Diocese of Phoenix Archives.)

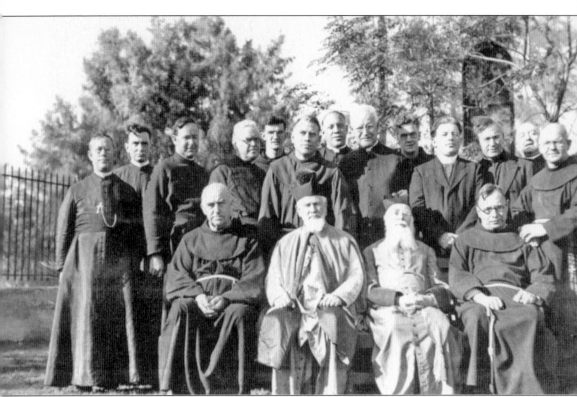

In 1931, Catholics came together to celebrate the 50th anniversary of the building of St. Mary's Catholic Church. In this anniversary photograph three religious orders of clergy are represented: Franciscans, Jesuits, and Claretians. On the left are Claretians, led by Fr. Antinimo Nebreda; in the center at very back are the Jesuits; and the remainder are Franciscans. In the first row, seated from left to right, are Novatus Benzing, Monsignor Timmerman, Msgr. Edward Gerard, and Fr. Martin Knauff. Gerard was a French priest who built the first Phoenix Catholic church in 1881. (Courtesy Catholic Diocese of Phoenix Archives.)

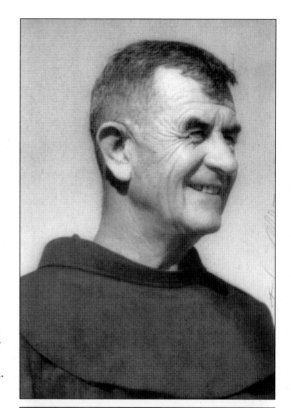

Fr. Albert Braun (above) and Fr. Emmett McLoughlin (below) were Franciscan priests who worked out of St. Mary's Catholic Church. Both men had a huge impact on the Mexican community of Phoenix. Father Braun came to Phoenix after a long career of working with the Mescalero Apaches in New Mexico and having received a Silver Star as a chaplain in both World War I and II. In World War II, he was captured by the Japanese and was a survivor of the Bataan Death March. He came to Phoenix in 1949 at the age of 61 and worked with the people in the Mexican barrio of Golden Gate, where he built the Church of Sacred Heart. He lived in Phoenix until his death in 1983. Father McLoughlin came to Phoenix in 1934. He soon began working in one of the poorest areas of Phoenix with both the black and Mexican residents. His work centered in the area surrounded by Seventh Avenue and Buckeye Road. He built St. Monica's Catholic Church at 809 South Seventh Avenue. (Above courtesy Tony Valenzuela; below courtesy Phoenix Memorial Hospital.)

Fr. Ferdinand Ortiz (left) and Father Marcos (below) were Mexican American Franciscan priests who worked out of St. Mary's Catholic Church. In the wake of the 1915 controversy, Father Ortiz was brought in to replace Father Novatus as the pastor of St. Mary's parish in 1922. Fr. Ortiz was the first person born in Arizona to become a Catholic priest. He was bilingual, spiritual, well-educated, and congenial. The non-Hispanic parishioners of St. Mary's would not accept him as pastor, and in 1924, Father Novatus was returned as pastor of St. Mary's. Father Marcos served for a short time at St. Mary's in the 1950s. (Left courtesy Franciscan Friars of the Province of Santa Barbara.)

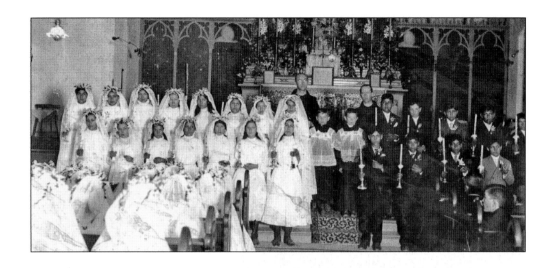

The first Holy Communion was always a special event for the Mexican American community. In both of these photographs, the event is memorialized with a group photograph. The photograph above was taken about 1905 in what was called the "Basement Church" of St. Mary's. The group is made up of Mexican American children, and Father Novatus is seen standing in the back on the left of the photograph. This photograph was taken before 1915 and the controversy over the English and Spanish language Masses. The lower photograph was taken in 1950 inside the auditorium of St. Mary's Grammar School. The class consists of a mixed ethnic group, and on the left is Fr. Victor Bucher.

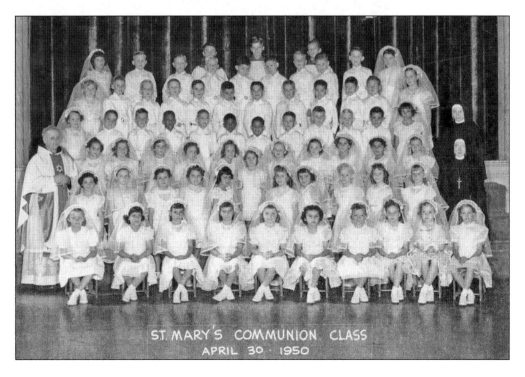

ST. MARY'S COMMUNION CLASS
APRIL 30 · 1950

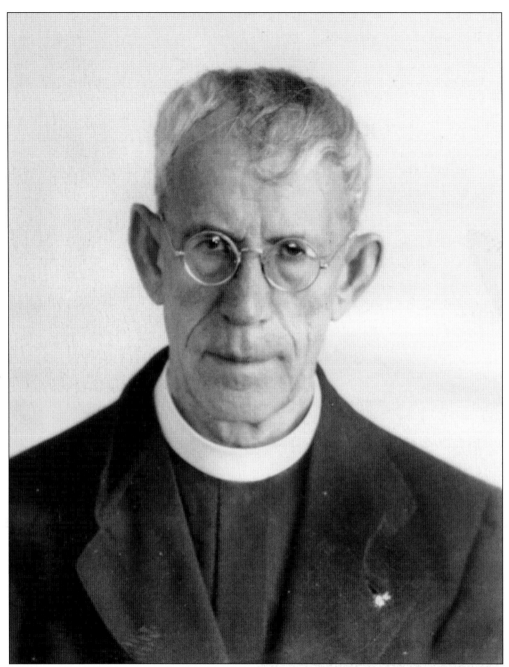

At some point following the turmoil of the 1915 incident, it was decided that the Spanish-speaking Ministry of Phoenix and surrounding areas would be best served by Claretian priests from Spain. The Claretian contingency was to be led by Fr. Antinimo Nebreda, who arrived in Phoenix on October 24, 1925. He was responsible for building the new church and for the Hispanic ministry of the surrounding areas of Phoenix. Father Nebreda was very well-respected and appreciated. He worked tirelessly getting the money to build the new church. Father Nebreda was the pastor of Immaculate Heart of Mary from 1925 to 1939. (Courtesy Claretian Missionaries of the U.S. Western Province, Los Angeles.)

In 1928, Immaculate Heart of Mary was completed. At the dedication, three bishops were in attendance: Bishop Daniel Gerke from the Diocese of Tucson; Bishop Juan Navarrett of Hermosillo, Sonora; and Bishop Augustin Aquirre of Sinaloa. The day was marked with a Mass and huge festivities. (Courtesy Catholic Diocese of Phoenix Archives.)

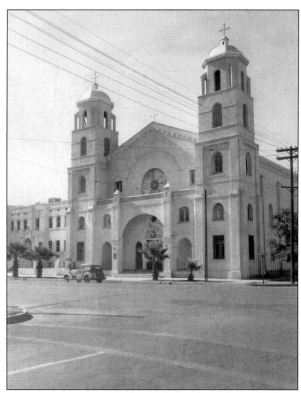

Fr. Jose R. Hurtado was born in Gilbert, Arizona, and was one of the most popular priests at Immaculate Heart. Gilbert served from 1971 until his death in a car accident near Prescott in 1981. He was well-loved by the parishioners. Hurtado was a political activist who spoke out on social welfare issues and in 1972 served as spokesman for the movement to recall Gov. Jack Williams because of Williams's position against Caesar Chavez and the farm-labor boycotts. (Courtesy Hurtado family.)

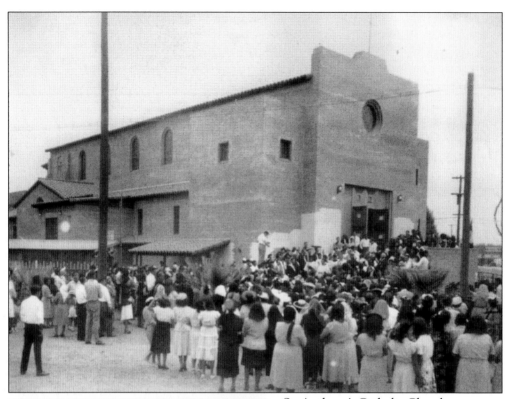

St. Anthony's Catholic Church, located at 909 South First Avenue, was constructed and dedicated in 1948. It was one of the Hispanic mission areas that were to be given to the Claretian Priests from Spain. It was located in a very poor Hispanic area of South Phoenix with an estimated parish population of 12,000 Spanish-speaking Catholics. This photograph was taken at the dedication ceremony on April 18, 1948. Bishop Gercke is in the photograph and was the major celebrant at the festivities. (Courtesy Catholic Diocese of Phoenix Archives.)

Although St. Anthony's Catholic Church was smaller than Immaculate Heart, it quickly became a center for community activity for the Spanish-speaking people of Phoenix. Many Claretian priests served at St. Anthony's, including Fr. Leo Labrador, shown in this 1956 photograph.

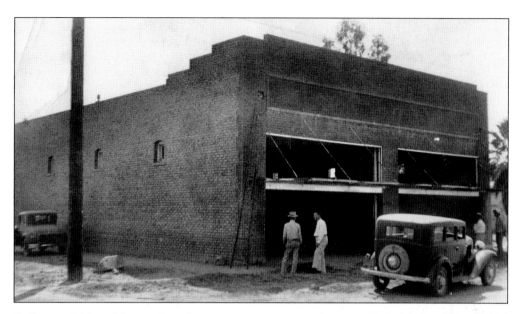

Fr. Emmett McLoughlin purchased a grocery store, converted it into a Catholic church, and called it St. Monica's. The photograph above shows the store being converted, and the photograph below shows the church as it stands today, now called St. Pius X. Father Emmett was also the founder of Memorial Hospital at Seventh Avenue and Buckeye Road and was responsible for bringing three major housing projects to Phoenix. In a conflict with the church, he left the priesthood, was married, and wrote a book titled *People's Padre*, in which he was critical of the Catholic church. (Above courtesy Catholic Diocese of Phoenix Archives.)

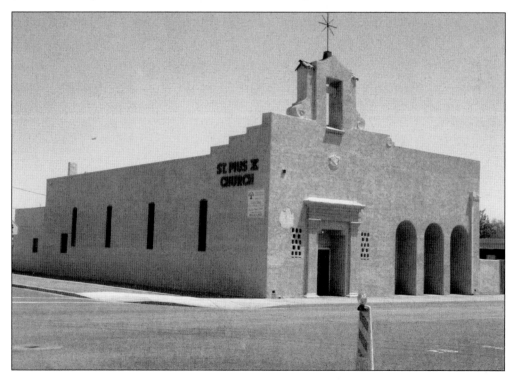

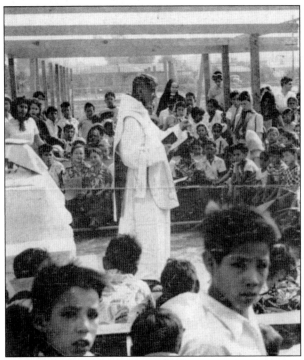

Fr. Albert Braun says Mass under a makeshift cover for a group of Mexican Americans in the Golden Gate barrio. Father Albert was dedicated to serving this group of people and promised that he would build them their own church. A favorite quote of Father Albert was if he were a bishop, he would close all the rectories and make the priests live and work with the people, where they belonged. (Courtesy Tony Valenzuela.)

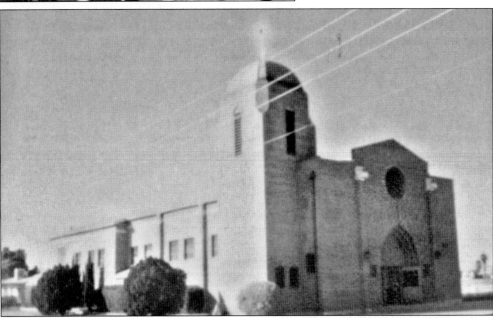

This is Sacred Heart Catholic Church, built by Fr. Albert Braun and located near Sixteenth Street and Buckeye Road. Legend has it that when he was short of money to build the church, Father Albert went to the poor of the Golden Gate barrio and asked each of them to bring him one brick so he could build them a church. He worked very hard to get this church built, and in 1952, Sacred Heart Church was completed. Today the church stands alone in a vacant area and can be seen from afar on the southbound Interstate 10 between Buckeye Road and Washington Street. (Courtesy Tony Valenzuela.)

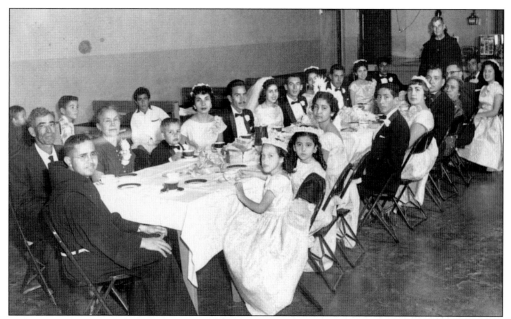

Father Albert was very community-minded and not only performed weddings and baptisms as a priest but also would then join the families in celebration afterward. This is a photograph of a wedding party following a wedding that he performed at Sacred Heart. Father Albert is standing at the end of the table, and the party was held at Calderon's ballroom, which was a short distance from the church. (Courtesy Calderon family.)

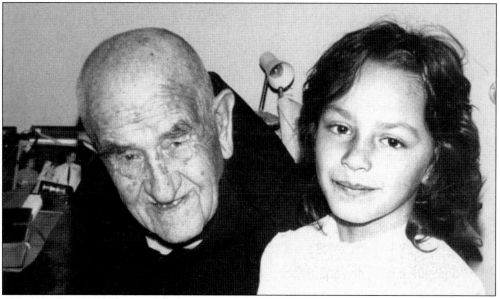

Father Albert retired to the Little Sisters of the Poor Home on South Sixteenth Street. No doubt many Mexican American families would bring their children to the home to meet Father Albert before he died in 1983 at the age of 93. For years he had worked with the Mescalero Apaches in New Mexico, and when he died they came to claim his body. Today he is buried underneath the altar at St. Joseph's Catholic Church in Mescalero, New Mexico. Albert built the church in New Mexico for the Apaches. (Courtesy Tony Valenzuela.)

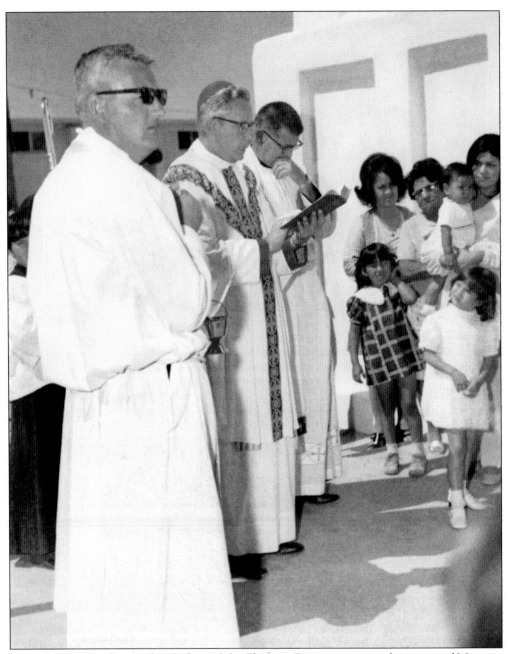

Edward A. McCarthy, the first bishop of the Phoenix Diocese, prays with a group of Mexican American families. Bishop McCarthy served from 1969 to 1976. Since creation of the Phoenix Diocese, there has been an ongoing effort to reach out to the Mexican American community. (Courtesy Catholic Diocese of Phoenix Archives.)

Five

THE PEOPLE

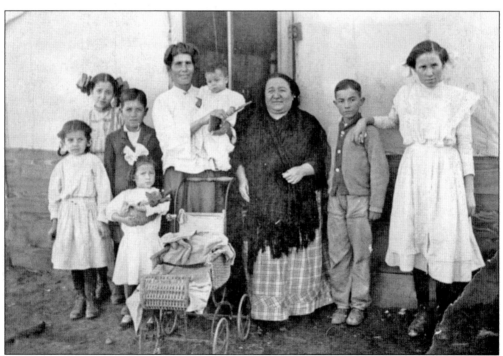

The Gold and Castro families pose for a photograph around 1910. Pictured from left to right are Elena Castro, Rose Gold (back), Cesar Castro, Dolores Gold (little girl with the large bow), Carmen Castro holding Alfredo Castro, Dolores Gold (black shawl), Dave Martinez, and Helen Gold. The large tent home in the background is the home Carmen and her children were living in.

Groups of young men and women would often join together to have their photographs taken, and then the photograph would be produced on a postcard that could be mailed. They probably shared the cost and then would send the photographs to friends and relatives.

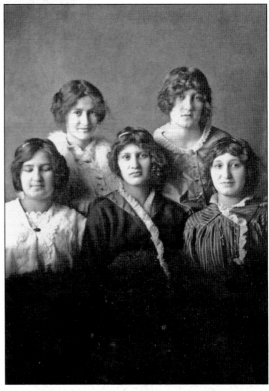

Sisters Helen (left) and Teresa Lopez were both prominent members of the Gold Alley community.

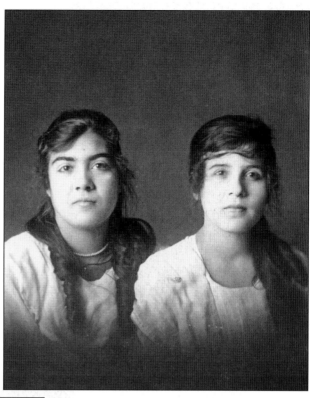

Featured in this photograph are Angelita Moreno (left) and her friend. The Moreno family was part of the early pioneer migration that came to Phoenix in the 1890s.

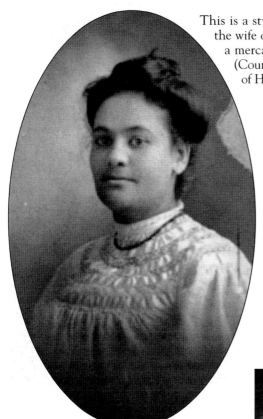

This is a stylized photograph of Concepcion Espinosa, the wife of Ignacio Espinosa, who owned and operated a mercantile store on Second and Jackson Streets. (Courtesy Romo family and the Phoenix Museum of History.)

Teresa Lopez was another prominent member of the Gold Alley community.

Brother and sister Enrique and Lupe Monreal had this picture made to commemorate a graduation. Enrique holds a document in his hand, probably a diploma.

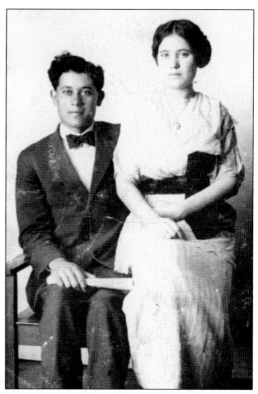

Brother and sister Macedonio and Isabel Vega, pictured around 1920, were the children of Jose and Julia Vega, who had in total seven daughters and five sons. The family came to Phoenix about 1912 from California. (Courtesy Katie Macias.)

This unidentified man and woman were also part of Mexican American community.

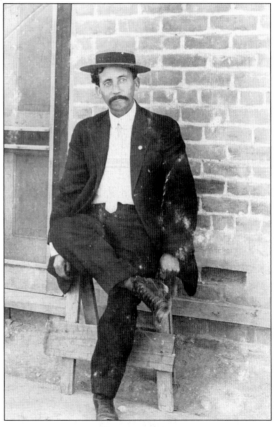

Theodora Gastelum was born in 1905 in Cananea, Mexico, and her brother Melecio was born in 1907. Their father, Julian, and mother, Guadalupe Luque Gastelum, first came to Arizona in 1914 and settled in Phoenix three years later. Theodora had three other brothers, Pablo, Fabian, and Jose, and two sisters, Frances and Tomacita. Their first home in Phoenix was on Eleventh and Jackson Streets. Theodora later married Tranquilino Reveles. Julian worked as a blacksmith and with the railroad. (Courtesy Julian Reveles.)

At a location around Fourth Street and Madison Street around 1922, Anna Loena and Rosa Boque pose in black dress, probably because they are in *luto*, a Mexican custom in which women dressed in black for a year or longer following the death of a close relative. (Courtesy Billy Hobaica family.)

A young Adam Diaz grew up in Phoenix and in 1953 became the first elected Mexican American city councilman in Phoenix's history. (Courtesy Adam Diaz family.)

Angel Delgado was the first Mexican American fireman in Phoenix. He served with the Yavapai Volunteer Fire station in Central Phoenix. (Courtesy Tillie Moreno.)

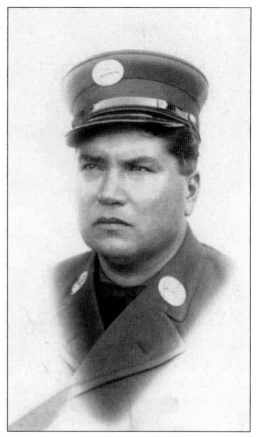

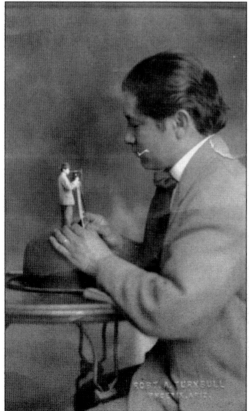

Robert A. Turnbull was a Mexican American photographer from Phoenix who would later move to Mexico and become famous for his spectacular photographs of the Mexican Revolution. This trick photograph, taken in Phoenix, shows Turnbull with a tiny photographer standing on top of a derby hat.

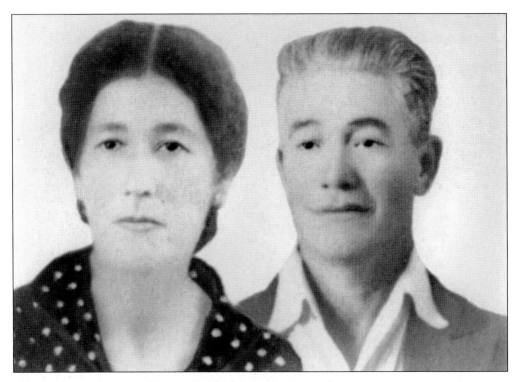

Above are Hipolito and Mauricia (Vega) Valenzuela, who were married in Phoenix in 1919 and eventually had a family of three girls and seven boys. Below is the Valenzuela family in 1955 with Mauricia and Hipolito seated near the center. (Both courtesy Katie Macias.)

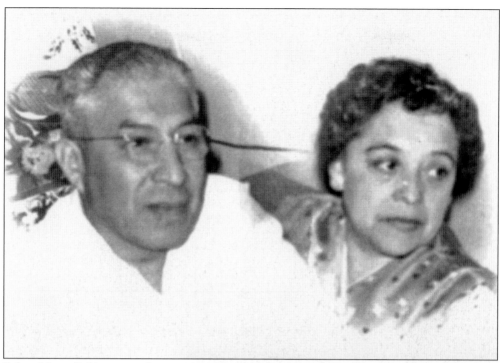

Sal and Lucy Balderas posed for a portrait (above) and are pictured dancing (right). The Balderases were very prominent in the Mexican community, and both were very politically involved. They also loved music, played in a band, and are often remembered for their singing and dancing. (Both courtesy Balderas family.)

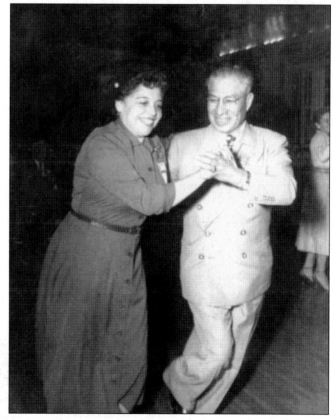

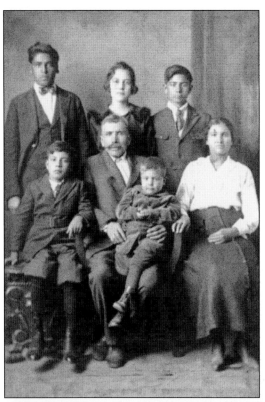

Pictured from left to right, the Duarte family was composed of (first row) unidentified, Rafael, Rafaelito, and Cruz; (second row) Francisco, Cuca, and Roberto. The family lived in what was called Las Avenidas; their home was around Eighth Avenue and Buckeye Road in Central Phoenix. (Courtesy Katie Macias.)

Manuel and Guadalupe de Torres are pictured with their family. From left to right are (first row, seated) Manuel and Guadalupe; (second row, standing) Enriqueta, Emma, and Cuca Torres. In 1930, Manuel opened one of Phoenix's first tortilla shops, calling it "El Metate" (stone corn grinder). It was located on Sixth and Madison Streets. He would later move his shop to a better location, at Fourth and Jefferson Streets, calling it "Superior Tamales." (Courtesy Rudy Domenzain.)

These photographs depict two Mexican Americans who served their country in World War I. In the photograph at right is Francisco "Frank" Valenzuela, whose father, Francisco Corosco Valenzuela, immigrated to Phoenix in 1877 from Hermosillo, Sonora. The photograph was taken in 1918 at Camp Dix just before Frank shipped out to Europe. He returned to Phoenix and married Maria Curiel, and they had four children, all raised in Phoenix. The photograph below shows, from left to right, Clara and Julio Maron and an unknown cousin. Julio is in uniform and posed for this photograph before going to fight in Europe. Julio and Clara are the children of Clara Woolsey, the daughter of King Woolsey, who never recognized Clara as his legitimate heir. Julio was killed in World War I and never returned to Phoenix. (Below courtesy Clara De La Cruz.)

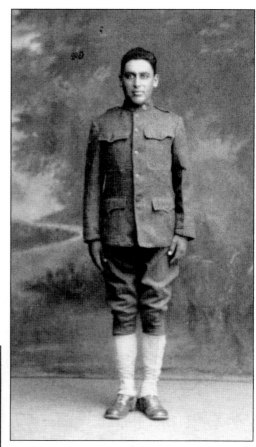

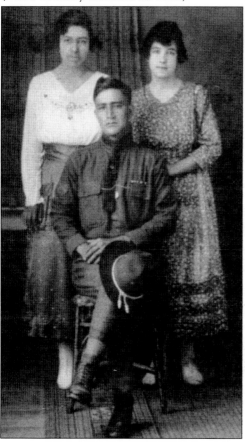

Ramon and Rachel (Gastelum) Andrade were born and married in Tubac, Arizona, then moved to Tempe, Arizona, in 1920, and to Phoenix in 1924. They had nine children, three girls and six boys, who were raised in West Phoenix at 3339 West Washington Street. Their oldest son, Raymond, started a very popular musical band in the 1950s and 1960s. (Courtesy Lynn and Richard Andrade.)

Vincent and Helen Canalez had four children and lived most of their life in Phoenix. Vincent was born in Christmas, Arizona, and grew up in Superior, Arizona, and Helen was born and raised in Tempe, Arizona. Vincent was a political figure in Phoenix and was owner of the Ramona Drug Store. (Courtesy William Canalez.)

Ramon and Carmen Cota had this portrait made to celebrate their 50th wedding anniversary. The Cotas had four children. Ramon was born in Nogales, Arizona, and Carmen was born and raised in Phoenix. She was a descendant of a pioneer Phoenix family that came to Phoenix in the 1890s. One of their daughters was Molly Cota, who was a famous Mexican American singer with the Pete Bugarin Band. (Courtesy Arsena Torres.)

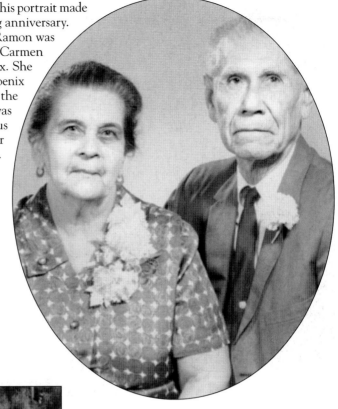

Enrique and Jesusita Cruz had six children, three girls and three boys, and raised them in the Sixteenth and Roosevelt Streets area of Phoenix. Enrique moved to Phoenix from Morenci in the 1930s and was the publisher of a Spanish-language newspaper called *El Valedor.* (Courtesy Gilbert Cruz.)

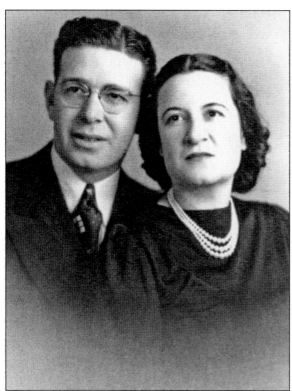

Alfonso Barrios was born in Southern California and came to Phoenix in the 1930s. His wife, Dolores, was a member of the Gold family, who were Phoenix pioneers. Alfonso was politically active and served in law enforcement all his life. They had one son, who is the author of this book.

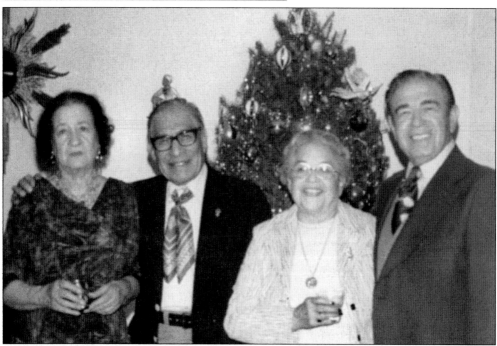

The Barrios and Balderas couples from left to right are Dolores, Sal, Lucy, and Alfonso. Alfonso and Dolores Barrios had a Christmas party every Christmas Eve at their home at 1330 East Osborn Road. Lucy and Sal would always attend, and all who were there had fun.

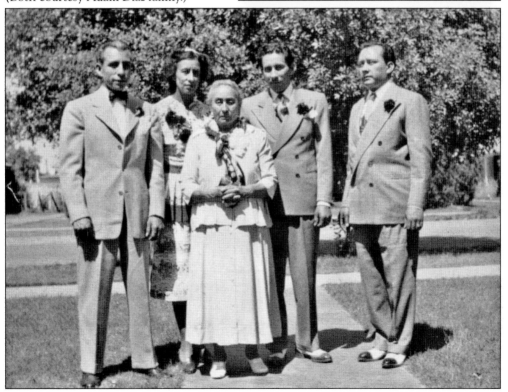

These two photographs are of the Adam Diaz family. The photograph at right is of Adam and his wife, Phyllis, and, from left to right, are his son Joe and daughters Sally, Olivia, and Mary Lou. Pictured in the photograph below are, from left to right, Adam Diaz, his mother, Soledad, his sister Aurora, and his brothers Virgil and Samuel. (Both courtesy Adam Diaz family.)

In the first row on the left are Albert and Maria Garcia posing with a group of friends in front of one of the tourist stores in Nogales, Sonora, in 1948. Albert was from Yuma and was a descendant of one of Arizona's oldest Mexican American families. He was a lawyer and served as an assistant attorney general for Arizona. His wife, Maria, was politically active at a time when few women were overtly political. She also was a good friend of Rose Mofford and a very strong Democrat.

Luis Medina was married to Micaela Medina. Luis was the cook at a popular Mexican restaurant La Cucaracha, located on Seventh Street just south of Indian School Road. While Luis cooked at La Cucaracha, his wife, Micaela, ran Rosita's Mexican Restaurant on Buckeye Road near Eighteenth Street. Eventually, La Cucaracha was closed, and the couple moved Rosita's to 2310 East McDowell Road, where it stands today. (Courtesy Medina family.)

Six

MAKING A LIVING

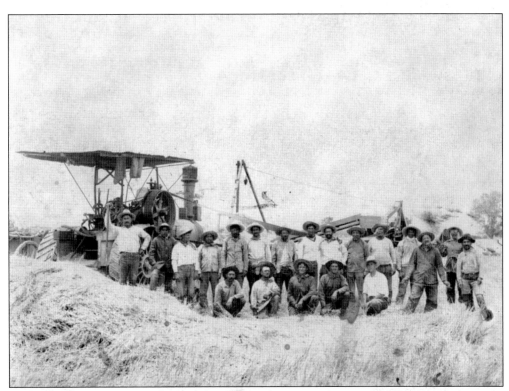

Agriculture has always been one of the major industries in Arizona and California. As it was then and is today, the success of agriculture is heavily dependent on the availability of a labor force. This photograph was taken in 1915 at one of the farms near Phoenix and shows a large Hispanic workforce that no doubt included Arizona natives and men who were born in Mexico and migrated to Phoenix looking for work.

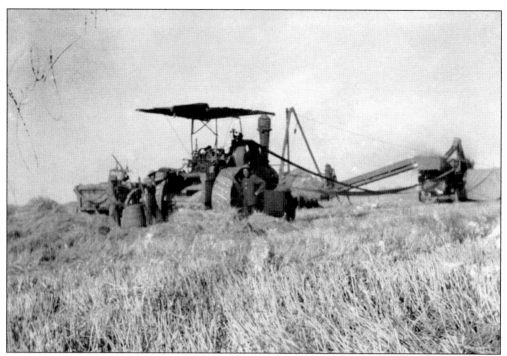

In 1915, Martin Gold ran a custom harvesting business and hired many Mexican American laborers. Martin owned a 65-horsepower case tractor that was converted to run on hay and provided a turn wheel with a large belt that powered the threshing machine. The work was hot and difficult and required the men to camp out in the field area for many days until the work was completed. Martin provided all the equipment and fed the men.

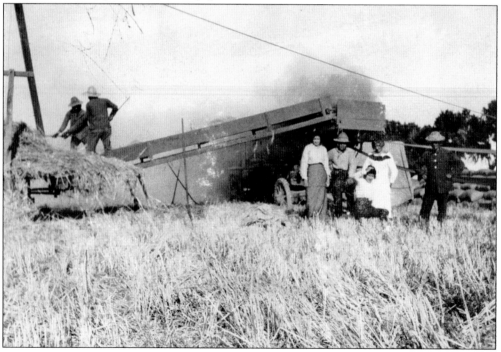

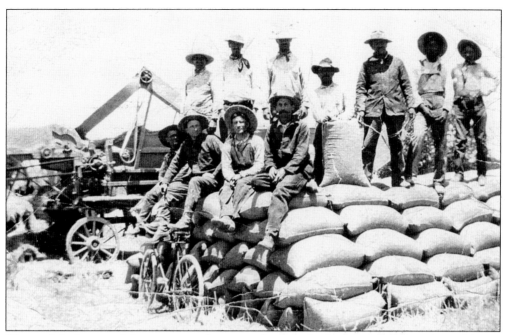

The work is done, and the men pose for group photograph. At the end of the project, Martin Gold would buy a keg of beer to celebrate a successful harvest. It was said that he treated all his employees fairly, and Gold's family members also worked alongside employees. In this photograph are his stepson Ulysses Schofield (seated in the center, with the large hat and light clothes) and his brother-in-law Pedro Martinez (standing third from right, in dark clothes).

At the end of the work, Martin Gold and his work crew would drive his motor-driven equipment and several horse-drawn wagons back to his home at 229 South Fourth Street (Gold Alley). In the photograph is a young boy unhitching the horses to put them away until another contract could be negotiated.

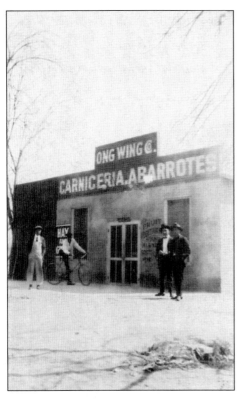

Many non-Hispanic citizens opened stores and businesses in Spanish-speaking neighborhoods and became proficient in Spanish in order to do business with the local Mexican Americans. In the photograph at left is the Ong Wing store, which was located in Central Phoenix and, as shown in the photograph, would advertise in Spanish. Many Chinese coming to Arizona were surprised that they had to learn Spanish before they learned English. The lower photograph is of the Lebanese Hobaica family: (from left to right) Shric, his son Albert, Arab, and their mother. The photograph was taken in Phoenix in the 1920s. The family came from Baskenta, Lebanon, speaking Spanish and Lebanese. They sold merchandise to the Spanish-speaking population and may have selected Phoenix because of the large numbers of Spanish-speaking people in the area. (Left, courtesy Phoenix Museum of History; below, courtesy Paul Hobaica.)

The Ramona Pharmacy was located at 325 East Washington Street in a primarily Mexican American business district. Today the area is under the Phoenix Civic Plaza. Robert T. Jones and Vincent Canalez originally owned the store, and eventually Jones sold his interest to Canalez, who became the sole owner. Robert T. Jones served as governor of Arizona from 1939 to 1941. The right photograph shows a typical advertisement for the Ramona Pharmacy. The photograph below shows a drug display located inside the Ramona Pharmacy. (Both courtesy William Canalez.)

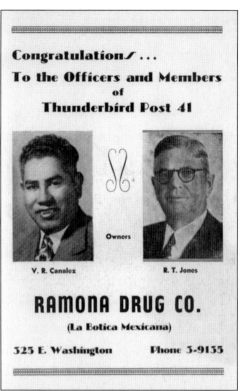

Congratulation/ ...

To the Officers and Members
of
Thunderbird Post 41

V. R. Canalez R. T. Jones

RAMONA DRUG CO.

(La Botica Mexicana)

325 E. Washington Phone 3-9135

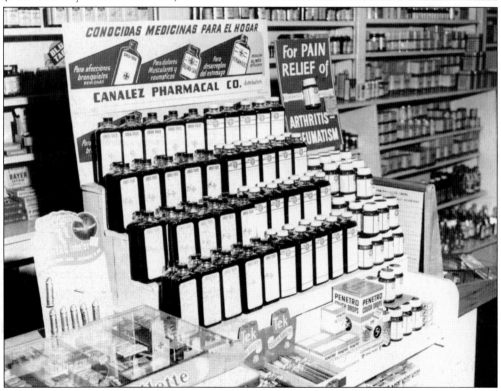

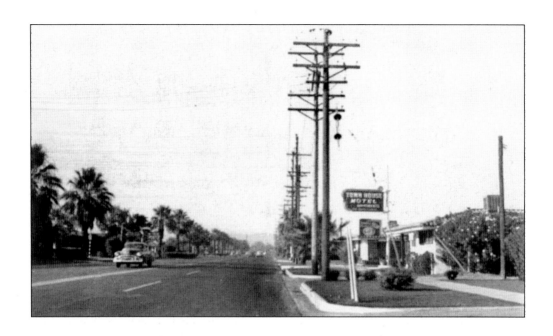

These two photographs, taken in the 1950s, are of the Town House Motel, located on Seventeenth Avenue just south of the railroad tracks and a short distance from the state capital. The motel was owned by Sal and Lucy Balderas, who were a politically active and prominent Mexican American couple. In the 1950s, Seventeenth Avenue was the gateway to Phoenix from California. Travelers would drive into Phoenix using Buckeye Road, turn down Seventeenth Avenue, and pass in front of the state capitol. It was a very nice area filled with many nice motels and apartments. Today the area is sadly seedy and gives no indication of its earlier glory. (Both courtesy Balderas family.)

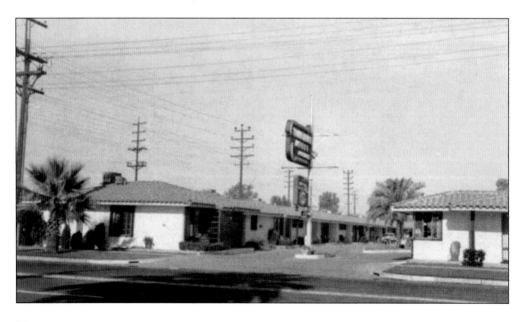

After the automobile was introduced to the Phoenix area, many found innovative ways to make a living using motorized vehicles. These two photographs were taken about 1915 in Phoenix. The above photograph shows Luis Killeen and his friends with two early vehicles. The below photograph shows a group of people riding on the Gila Stage Line. The man on the passenger side of the vehicle is David Martinez. To what extent the Mexican American community was involved in making a living with automobiles can only be speculated.

QUIERE USTED VERDADEROS ANTOJITOS MEXICANOS. LOS ENCUENTRA EN "EL REY CAFE"

GABRIEL PERALTA

El Rey Cafe

EL MAS ELEGANTE RESTAURANT MEXICANO DE PHOENIX

Toda clase de platillos mexicanos de la mejor calidad. Abierto todos los días y también por las noches.

Se sirve CERVEZA DE LA MEJOR. Este establecimiento es un restaurant de orden, propio para familias.

LIMPIEZA — CORTESIA

GABRIEL PERALTA, Propietario.

922 South Central Ave. Teléfono: 4-4678

Cerrado solamente los Lunes

Just as today, good Mexican food was always very popular, and owning a Mexican restaurant was always a successful way of making of living. Two prominent Mexican American restaurant owners were Gabriel Peralta and Frank "Pipa" Fuentes, two of the most successful in Phoenix. They also were political and served many leadership positions in Phoenix in the 1940s and 1950s. The left photograph shows a Spanish-language advertisement for the El Rey Café owned by Gabriel Peralta and located at 922 South Central Avenue. The photograph below shows a Spanish-language advertisement for La Poblanita Café owned by Pipa Fuentes and located at 205 East Jefferson Street. Fuentes was very prominent with American Legion Post 41 and in conjunction with Ray Matinez was instrumental in implementing civil rights changes in the Mexican American community of Phoenix. (Both courtesy Arsena Torres.)

La Poblanita Cafe

El Restaurant donde encuentran toda clase de platillos mexicanos de la mejor calidad;

Enchiladas, Taquitos, Tamales, y sobre todo rico menudo y tortillas de maíz y de harina estilo sonora.

Si quieren comida fresca y rica, servicio eficaz y completa limpieza, venqan a

La Poblanita Cafe

FRANK (Pipa) FUENTES

Propietario.

205 E. Jefferson St. Teléfono: 3-2442

Phoenix, Arizona.

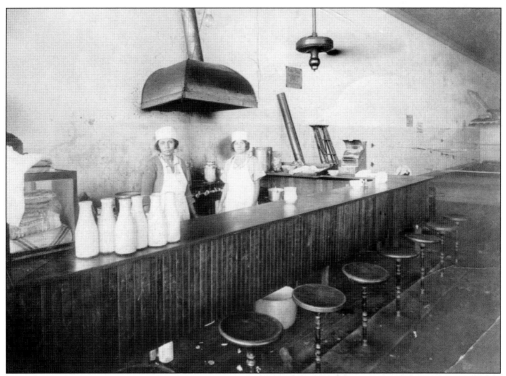

There were many Mexican restaurants throughout Phoenix. Some were small mom-and-pop neighborhood restaurants, while others were in better locations. The above photograph was taken inside a small restaurant named El Sonorense at Third and Buchanan Streets. The photograph below shows the Del Mar Cafe, which represents a typical Mexican restaurant in South Phoenix. (Above courtesy Mary Walker Camarena.)

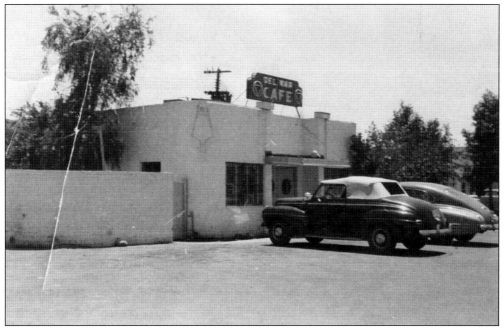

Although Phoenix was not the largest city in Arizona, it had more Spanish-language newspapers than any other city in the state. The photograph at left shows a copy of the Spanish-language *El Valedor*, published by Enrique Cruz. Cruz lived in the Sixteenth and Roosevelt Streets area and published the newspaper out of his home. Enrique is shown in the photograph below working at his printing press. *El Valedor* was a small neighborhood newspaper that had quite a bit of advertisements in it. (Both courtesy Gilbert Cruz.)

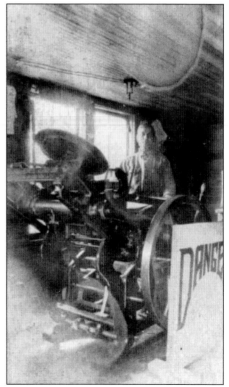

The two largest Spanish language newspapers were *El Mensajero* and *El Sol*. A copy of a 1927 issue of *El Mensajero*, published by Jesus M. Melendrez—who was also one of the founders of La Liga Protectora Latina—is pictured at right. Below is an issue statement of one of *El Sol*'s publications and was published by Jesus and Josefina Franco, who were both powerful leaders in Phoenix's Mexican community in the 1940s. They were both credited with starting Las Fiestas Partrias, an important celebration in the Mexican community. *El Sol* was a much larger newspaper than *El Mensajero*. (Below courtesy Arsena Torres.)

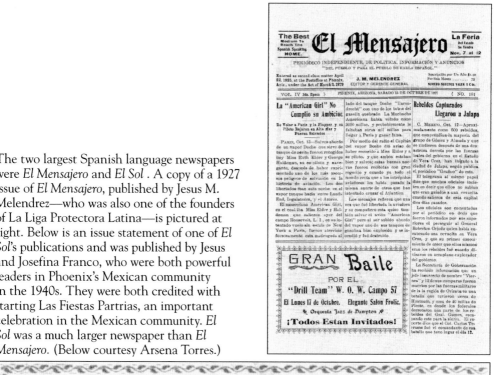

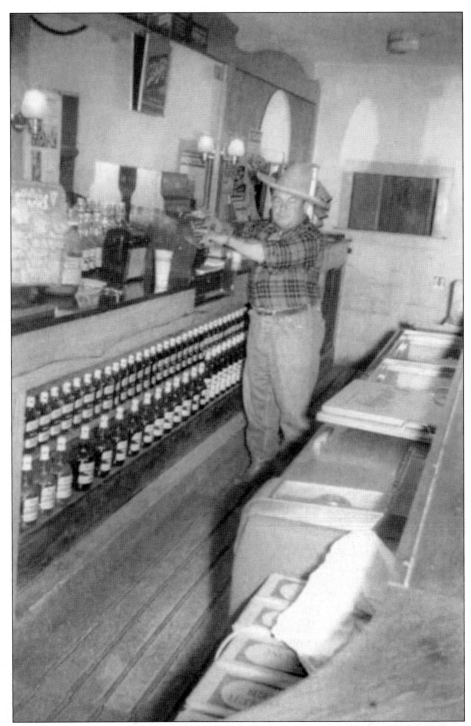

What community or barrio area was complete without its cantina? This could range from the large, extravagant ballroom bars to the corner cantina where good friends could meet on a regular basis. The photograph shows the large bar at Calderon's Ballroom built in the midst of the Golden Gate neighborhood. (Courtesy Calderon family.)

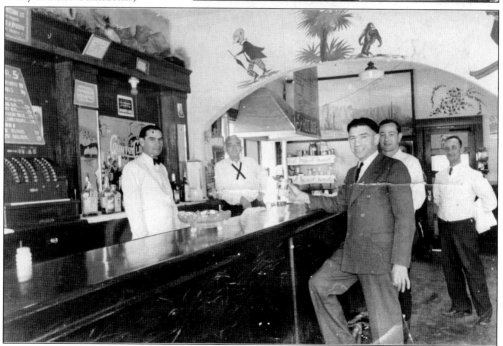

These photographs are of smaller bars that were located in neighborhood areas within the Mexican community. El Sonorense, shown at right, was located around Third and Buchanan Streets. The photograph below was taken inside the Gold Spot, a bar located in the industrial area often referred to as La Marketa, around Madison and Fifth Streets. (Right courtesy Mary Walker Camarena.)

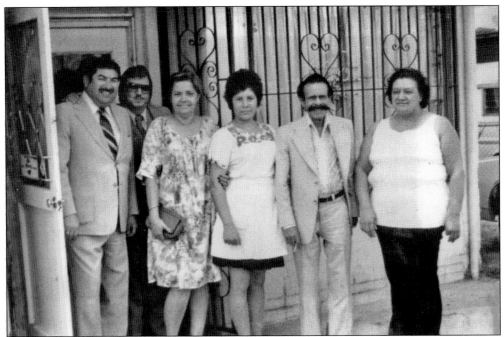

This photograph was taken outside Rosita's Mexican Restaurant, when it was located around Eighteenth Street and Buckeye Road. Micaela Medina, the proprietor of the restaurant, is on the far right; next to her is Pepe Acosta, with his large mustache; and in the center in the floral dress is Christina Rivera, a longtime waitress who had worked with the family for years and who moved with them when they relocated their restaurant to 2310 East McDowell Road, where it is today. (Courtesy Medina family.)

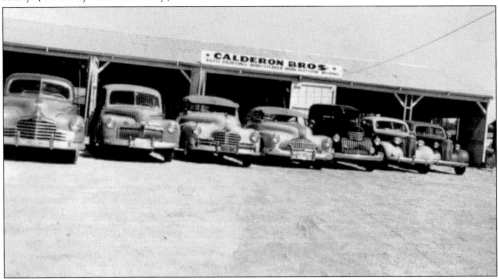

Leonard Calderon was always known for the Calderon Ballroom and his involvement in the entertainment business. But before he was involved in the entertainment business, he had worked with his brother Joe in the automobile-repair business. The photograph shows the Calderon Brothers Auto Body and Paint Shop, located at 610 East Henshaw Road, later Buckeye Road. (Courtesy Calderon family.)

Seven

MUSIC AND ENTERTAINMENT

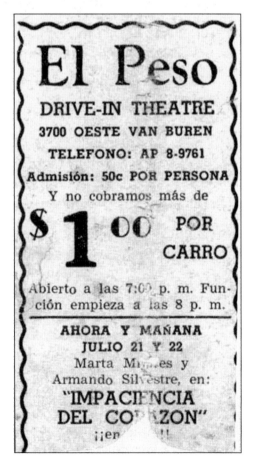

Music and entertainment were, and still are, an important part of the Mexican American community. In the early years, performances started with street dances and local vaudeville and transitioned into movies and radio programs and eventually into the ballroom extravaganzas with popular bands and their singers. The photograph is a local newspaper advertisement for the El Peso Drive-in theater, located at 3700 West Van Buren Street. As the name implies, the cost of the drive-in theater was $1 per car. (Courtesy Arsena Torres.)

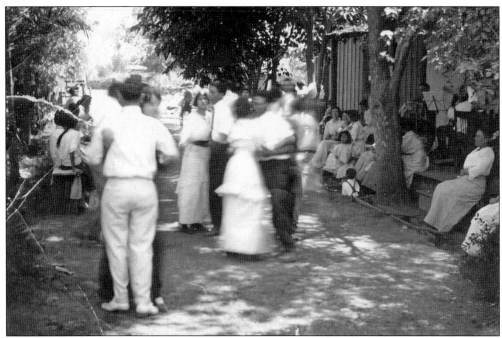

An early 1915 street dance in Phoenix is pictured here. It should be noted that the older ladies, on the right in the photograph, are closely watching to make certain that proper decorum is observed. Also on the right, one can see part of the band playing.

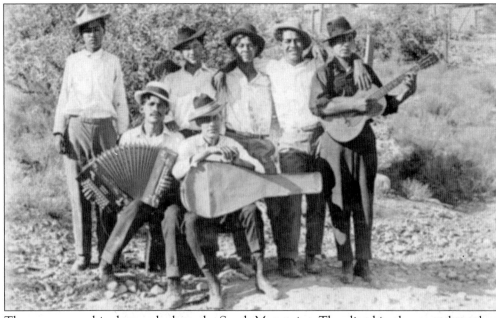

These men were hired to work along the South Mountains. They lived in the area where they worked and were no doubt camping out. They brought their musical instruments with them and would entertain themselves at night around the campfire with music and song. Hipolito Valenzuela is the second man on the right; the names of other men are unknown. (Courtesy Katie Macias.)

This 1920s photograph shows brother and sister Manuel and Isabel Vega singing the popular songs of the day. (Courtesy Katie Macias.)

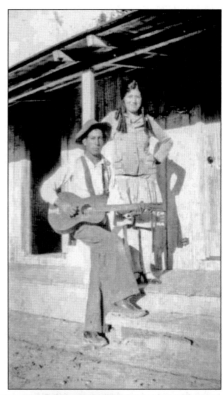

A family serenade could be heard coming from the home of Ramon and Rachel Andrade, at 3339 West Washington, around 1940. On the left with the guitar, is son Raymond who would eventually start his own band, which was popular in the 1950s and 1960s. In the center is Ramon playing the accordion. The other men in the photograph are not identified. (Courtesy Lynn and Richard Andrade.)

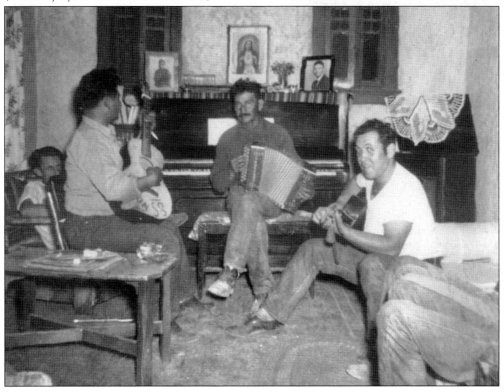

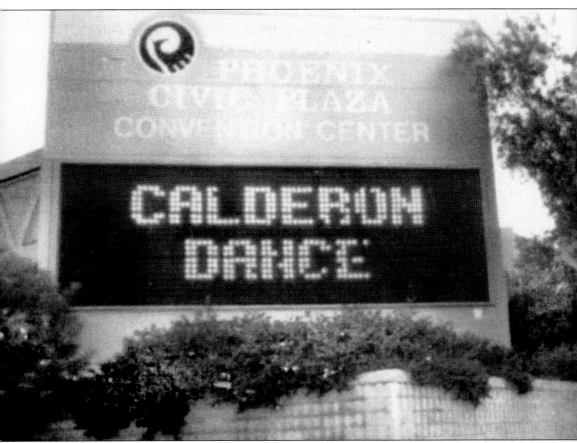

The Mexican American community of Phoenix always enjoyed large-scale ballroom entertainment, and throughout the history of Phoenix, places like the Plantation, Riverside Ballroom, and the Willow Breeze were all major centers for this type of entertainment. But one of the greatest of these large-scale entertainment facilities was the Calderon Ballroom. It was started by Leonard Calderon and soon became one of the most popular places in the Mexican American community. The photograph shows a sign at the Phoenix Civic Plaza announcing a Calderon-sponsored Dance. (Courtesy Calderon family.)

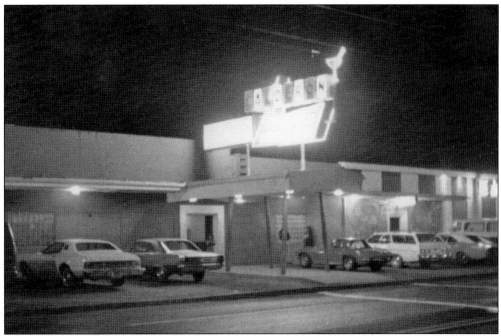

The Calderon Ballroom is shown above at night. Below is a caricature painting of Leonard Calderon painted on the inside wall of the ballroom. Calderon's was located near Sixteenth Street and Buckeye Road, and today all of the land in this area lies barren except for Sacred Heart Church, which stands alone. The area was once known as the Golden Gate barrio, and all of the buildings were bought out for the downtown airport redevelopment. (Both courtesy Calderon family.)

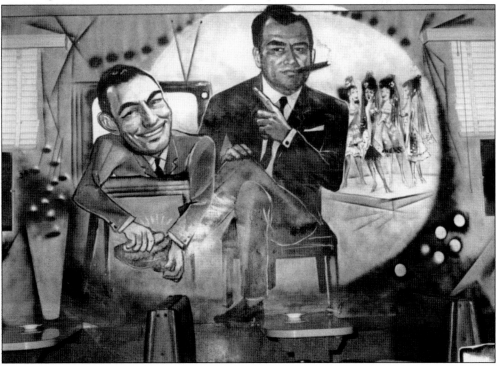

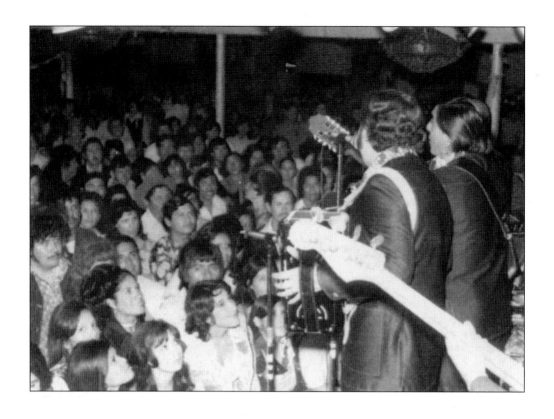

These two photographs show a typical evening at Calderon's. Above, a crowd listens to a musical group, and the photograph below shows an evening of dancing. (Above, courtesy Calderon family; below, courtesy Ray Gano.)

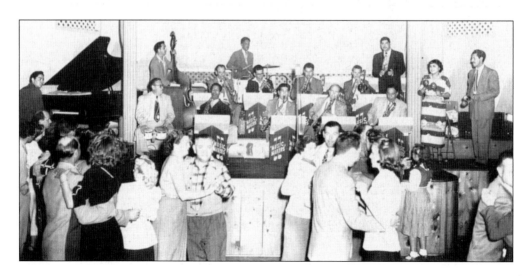

This 1958 photograph shows Leonard Calderon sponsoring a March of Dimes fund-raising event at the ballroom. Leonard (far left) was politically active and very strongly committed to public service. (Courtesy Calderon family.)

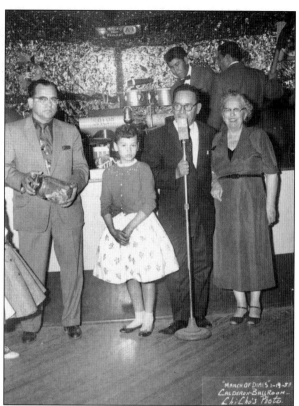

This photograph shows an advertisement for the Ike and Tina Turner Review. In the 1950s and 1960s, black entertainment had a difficult time finding a location where they could perform in Phoenix. Calderon was one of the few large-scale entertainment center owners that would contract with black performers. As a result, performers such as Lionel Hampton, Fats Domino, Little Richard, Ray Charles, and Ike and Tina all performed at the Calderon Ballroom. (Courtesy Calderon family.)

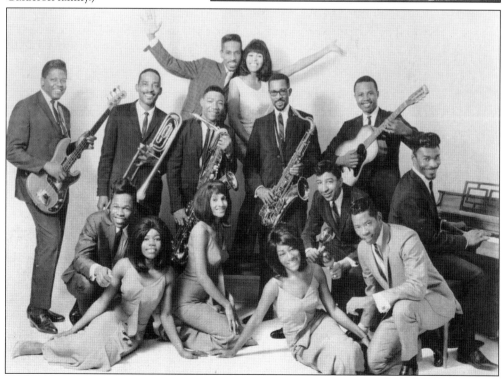

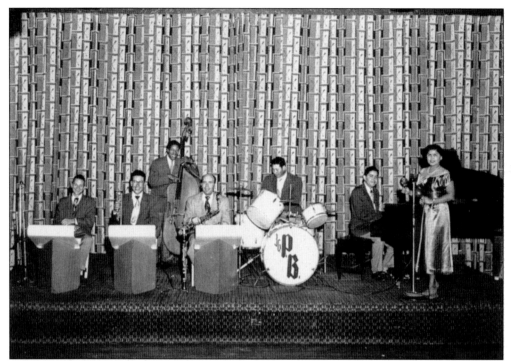

From the 1940s through the 1970s, Pete Bugarin and Chano Acevedo were two of the most well-known orchestras of the Mexican American community. Although both were formed in the Phoenix area, they became known throughout the state of Arizona. Above, the Bugarin Orchestra and its most famous female singer Molly Cota are pictured. Below is the Acevedo Orchestra. (Both courtesy Ray Gano.)

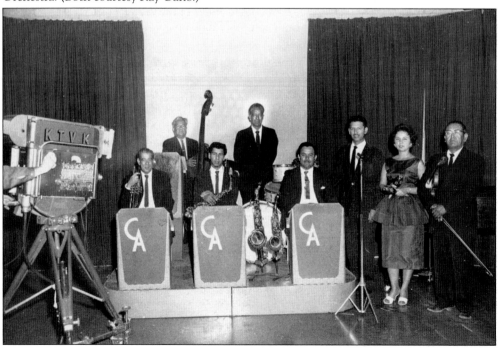

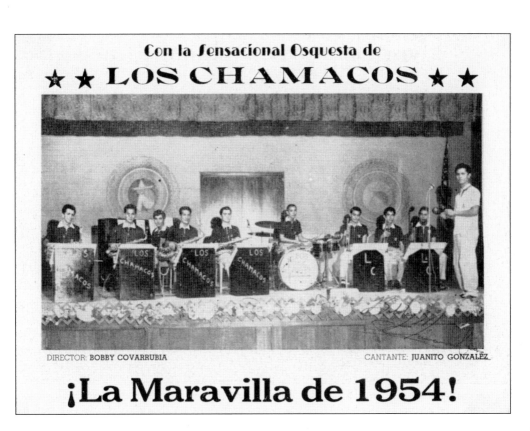

Con la **fensacional** Osquesta de

★ ★ LOS CHAMACOS ★ ★

DIRECTOR: **BOBBY COVARRUBIA** CANTANTE: **JUANITO GONZALÉZ**

¡La Maravilla de 1954!

These two photographs show other Phoenix orchestras that performed within the Mexican American community. A group called Los Chamacos (the Kids) are pictured above; below is an unidentified mariachi group. Other famous performers of the era include orchestras led by Chapito Chavarria and Luis Estrada. (Both courtesy Calderon family.)

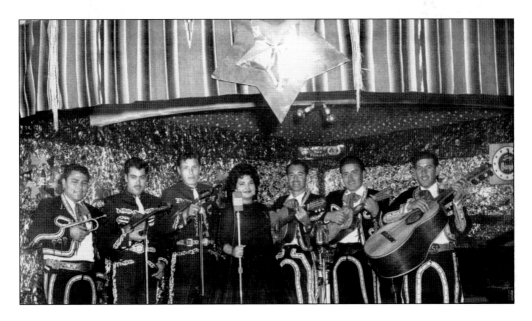

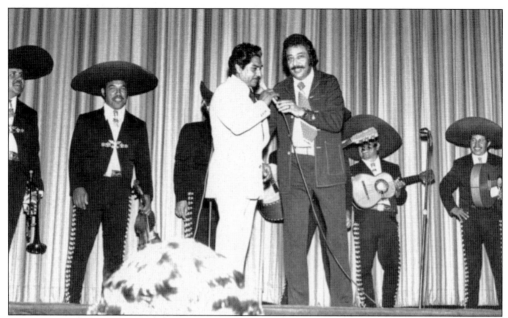

This is a photograph of Felix Corona (in white suit) and Humberto Preciado (in dark suit) with the mariachi group Alma Jalicience in the background. This photograph was taken on the stage inside Palace West Theater, which today is owned by the City of Phoenix and has returned to its original name of the Orpheum Theater. In the 1960s, Felix Corona purchased the old Paramount movie theater and began showing Spanish-language movies and live Mexican entertainment for several years thereafter. Today Corona owns Corona Ranch, a rodeo-type facility located at Twenty-seventh Avenue and Baseline Road. (Courtesy Humberto Preciado.)

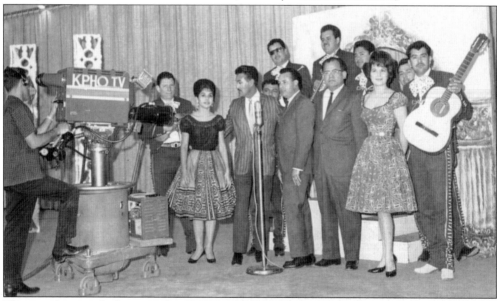

This is a photograph showing a live KPHO television taping of a group of musicians and singers. The musical orchestra is Alma Jalicience, and the master of ceremonies is Hector Ledesma (center, striped jacket), a prominent television personality in the 1960s and 1970s. Also in the photograph is Leonard Calderon (first row, third from right). (Courtesy Calderon family.)

110

One of the most popular Mexican vocalists of her time was Molly Cota. She was married to William Scott, and they had a daughter and four sons. She often sang with Pete Bugarin and his orchestra but had a strong following throughout the Southwest. She was known as "La Chatita" (pug nose). The photograph at right shows Cota in a traditional Mexican dress. Below, she is shown with Tencha Leon, another well-known Mexican singer. The two would often sing duets together. (Both courtesy Arsena Torres.)

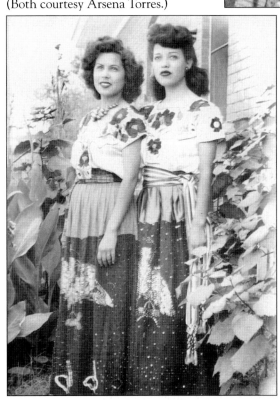

"LA VOZ MEXICANA" DIAL 860

Spanish-language radio became a huge medium for entertainment and communication in the Mexican American community of Phoenix. The photograph shows a cartoon caricature of the disc jockeys who were working for KIFN radio in Phoenix in 1969. The cartoon is titled " 'La Voz Mexicana' Dial 860" and included an advertisement for Canyon Ford. (Courtesy Humberto Preciado.)

Longtime entertainment personality and radio disc jockey Humberto Preciado is shown hosting one of his radio shows on KIFN radio. Huberto was born in Nogales, Sonora, and has resided in Phoenix since 1954. Humberto started his radio career in 1960 with KZON radio. He has remained in Spanish-language radio ever since and currently works with KSUN radio. (Courtesy Humberto Preciado.)

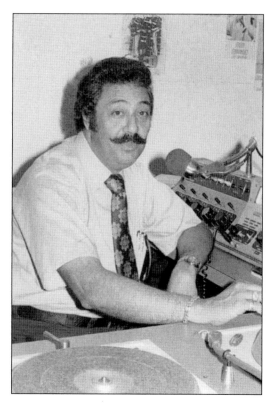

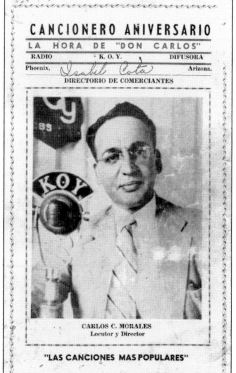

CANCIONERO ANIVERSARIO

LA HORA DE "DON CARLOS"

RADIO K. O. Y. DIFUSORA

Phoenix, *Isabel Cota* Arizona.

DIRECTORIO DE COMERCIANTES

CARLOS C. MORALES
Locutor y Director

"LAS CANCIONES MAS POPULARES"

The photograph shows a Spanish-language advertisement for *La Hora De Don Carlos*, a popular radio program hosted by Carlos Morales on KOY radio. Morales was not only a very popular radio host, but was also a community leader who was very involved in the politics of the Mexican American community. KOY was the first radio station to host Spanish-language radio in Phoenix. Other important radio hosts included Raphael "Ralph" Gaxiola and Carlos Montano. (Courtesy Arsena Torres.)

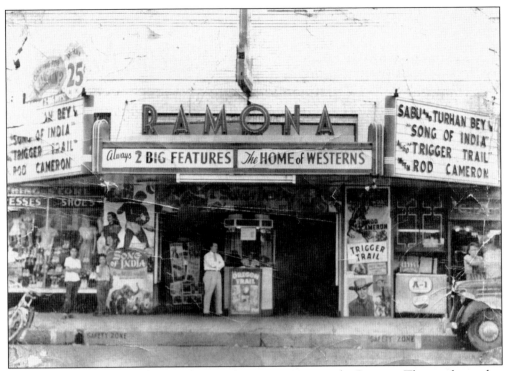

The first movie theater built in a Mexican American area was the Ramona Theater, located at 339 East Washington. In the earliest years, the Ramona Theater also hosted Spanish-language vaudeville shows from Mexico. The above photograph was taken in the 1940s and shows the front and entrance to the theater. The 1920s photograph below shows the same entrance from a different time period. (Above courtesy George Metsopolos.)

The other two movie theaters built in the Mexican American area were the Rex and the Azteca. The photograph at right shows general type advertisements for the Azteca and the Rex The lower photograph shows a specific Azteca advertisement announcing the names of the movies that were playing and the times that the Spanish-language movies were being shown. It also contains images from the movies playing. (Both courtesy Arsena Torres.)

Teatro Azteca

El suntuoso palacio del arte mexicano que es orgullo de nuestra Colonia en el Valle del Río Salado

Las mejores y más nuevas películas mexicanas, ... cada semana hay estreno de películas.

SABADO, — DOMINGO, — LUNES

206 E. Washington St. Teléfono: 4-3227

ARTHUR KEMPTON, Mgr.

Teatro Rex

Constante exhibición de películas mexicanas de la mejor calidad a precios populares.

EL TEATRO REX ha sido simpre el teatro preferido de los mexicanos.

... Cambio de películas DONMINGO y JUEVES ...

212 E. Washington St. Teléfono: 4-4367
L. C. BAKER, Mgr.

The Mexican American community participated in many types of celebrations, both local and involving the entire city. The photograph shows a small float probably used to celebrate a local event or to gather support for a fund-raiser. It appears to be moving down a street in one of Phoenix's barrios. Radio personality Humberto Preciado is following the float holding a microphone and reporting on the event to one of the Spanish-language radio stations. (Courtesy Humberto Preciado.)

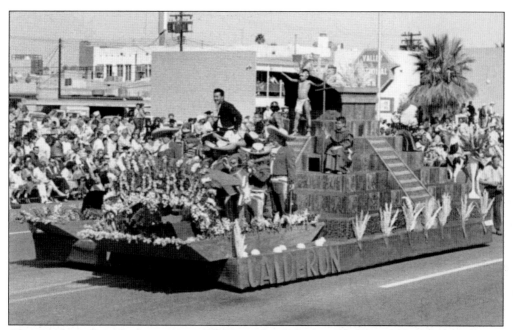

Above, a large float depicts an Aztec theme; radio and television personality Hector Ledesma sits in the center and waves to bystanders. On the side of the float is the word "Calderon," no doubt sponsored by the Calderon Ballroom. The lower photograph shows a group of mariachis playing on top of a lavish float, and on the side are the letters APS, representing Arizona Public Service. (Both courtesy Calderon family.)

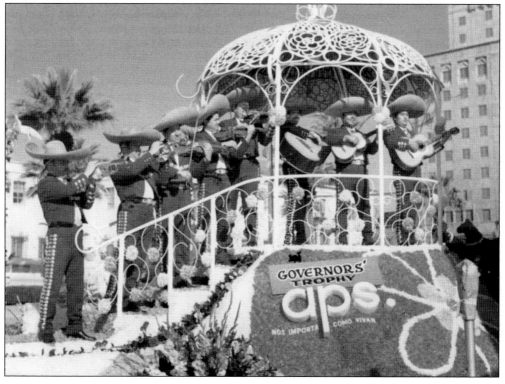

Gov. Sam Goddard poses with Jose Alfredo Jimenez, a famous Mexican composer and singer who is dressed in a traditional mariachi outfit. The photograph was taken at some major celebration probably held somewhere near the Calderon Ballroom. (Courtesy Calderon family.)

Eight

LEADERSHIP

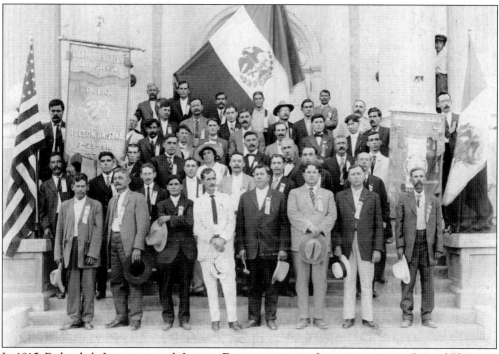

In 1915, Pedro de la Lama met with Ignacio Espinosa, owner of a grocery store in Central Phoenix, and Jesus Melendrez, publisher of the Spanish-language newspaper *El Mensajero,* and others. They came together to create La Liga Protectora Latina (the Latin Protection League). It was one of the first major civil rights organizations of the 20th century in Phoenix. The photograph shows La Liga at one of their conventions. The photograph was taken about 1917 in Tucson, Arizona. The man in front in the white suit is de la Lama; he was well-educated and had been an officer in the Mexican Army when he came to Arizona in 1886 and arrived in Phoenix in 1893. He lived to be 92 years old and died in Phoenix in 1945. In the first row, to the right of de la Lama is Dr. Lorenzo Boido, and the second person from the right is Ignacio Espinosa. The man on the far left is Jesus Melendrez. (Courtesy Romo family and Phoenix Museum of History.)

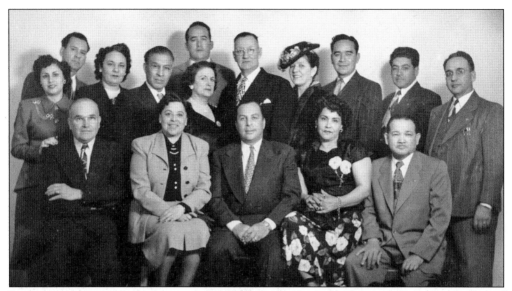

In this group photograph taken in the 1940s are several people who were prominent leaders of their times. From left to right are (first row, seated) Gabriel Peralta, Lucy Balderas, Abraham Salcido, unidentified, and Art Van Haren; (second row includes, standing) Sal Balderas (fourth from right), Louis Killeen (fifth from right), Jesus and Josefina Franco (seventh and eighth from right), Gustavo Rodriquez (third from left), and Carlos Morales (far left). The most well-known were the Francos, owners and publishers of *El Sol*, and Morales, who was the most famous personality on the radio.

In 1999, the League of United Latin American Citizens (LULAC) hosted a special tribute to Arizona's Hispanic community called Profiles of Achievement. This photograph was taken in the governor's office showing the honorees with then-governor Jane Hull. The list of those people honored included the following: Chano Acevedo, Pete Bugarin, Frank Camacho, Luis Estrada, Homer Lane, Humberto Preciado, Adam Diaz, Ronnie Lopez, Olivia Moran, Ed Pastor, Mauel Pena, Steve Zozaya, Gwen Bedford, George Brooks, Julius Bowman, Frank Carrillo, Sylvestre Herrera, Sue Gilbertson, Julia Zozaya, Robert Castillo, Mary Jo French, Cesar Marin, Eugene Marin, Anita Ramos, Jose De Jesus Vega, and Santos Vega. (Courtesy Ray Gano.)

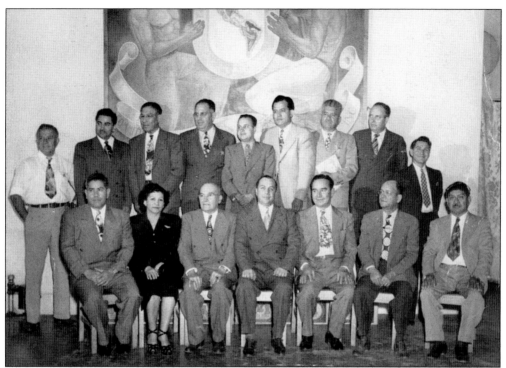

These two 1950s photographs show the members of the Mexican Chamber of Commerce of Phoenix. The general membership is pictured above, while the photograph below shows the executive committee with (from left to right) Leonard Calderon, secretary; Gustavo Rodriquez; Nataila de Bustos; Abraham Salcido, president; Gabriel Peralta, vice president; and Natalio E. Velazques, treasurer. (Both courtesy Calderon family.)

Featured in this photograph is an elderly Vincent Canalez, the proprietor of the Ramona Drugs Store in Central Phoenix. He was also a political activist who would support certain non-Hispanic candidates for public office in return for their political support of the Mexican American community. At a time when the Mexican American community had no political representation, Canalez provided a valuable service to his people. Luis Cordova, father of Val Cordova, was also a political activist who worked in a similar way for his community. (Courtesy William Canalez.)

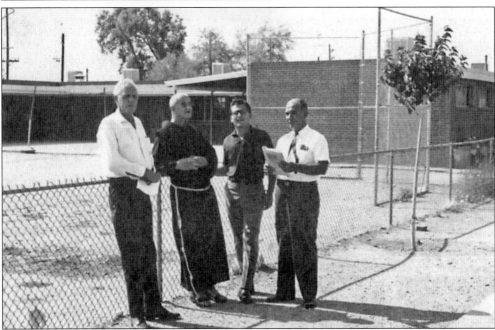

In the schoolyard in the Golden Gate barrio are, from left to right, Ramon Arvizu, Fr. Albert Braun, Nano Calderon, and Pete Avila. In each barrio of Central Phoenix, there was always a group of men looked upon as leaders of their community. These men were the leaders of the Golden Gate area. (Courtesy Calderon family.)

This is a photograph taken in the 1960s, and from left to right are an unidentified individual, Eugene Marin, Gov. Paul Fannin, and Sal Balderas. In the 1960s, most Mexican Americans from Phoenix were Democrats, but a few were Republicans. Eugene Marin and Sal Balderas were prominent leaders of their community and were both Republicans. No doubt they provided many benefits to their community from the Republican side of the political spectrum. (Courtesy Balderas family.)

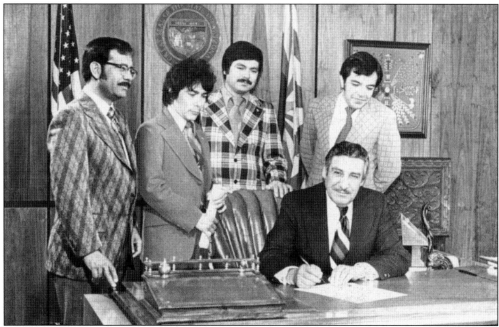

The League of Latin American Citizens (LULAC) members meet with Governor Castro while signing a proclamation in support of a LULAC event. From left to right are Frank Carrillo, unidentified, Ray Gano, and J. J. Garcia. (Courtesy Ran Gano.)

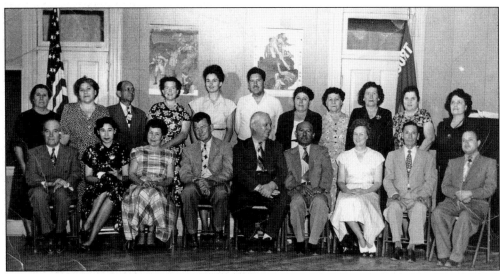

This 1940s photograph shows a local Phoenix leadership group Los Amigos (the friends), and from left to right are (seated) Gabriel Peralta; Romelia Laito; Maria Garcia, who was president of the group; John Flood; Thomas Crow; Jose Larranaga; Maria Colb; Rafael Granados; and Enrique Medina; (standing) Maria Gutierrez; Ines Garcia; Natalio Velazquez; Flora Webster; Mrs. Al J. Flood; Ray Martinez; Enriqueta Lewis; Amalia Elias; Elena Killeen; Amelia Oviedo; and Margarita Miramon.

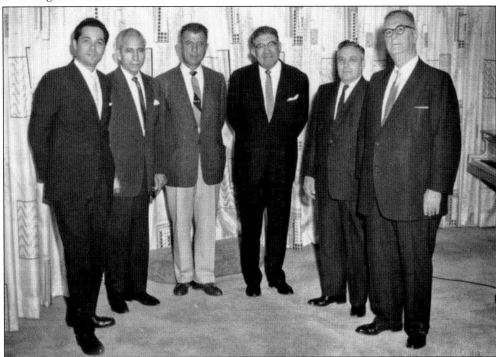

From left to right are Val Cordova, Adam Diaz, Jay Rosell, Amb. C. Carrillo, unidentified, and Rudolph Zepeda with Valley National Bank of Arizona. This photograph represents one of the typical meetings regularly held at city hall. Adam Diaz, as previously noted, was the first elected Mexican American city councilman for Phoenix. (Courtesy Adam Diaz family.)

These photographs recognize Alfonso Barrios and Ray Gano, two longtime members of the League of Latin American Citizens (LULAC). In the photograph at right is Alfonso Barrios, Alianza's man of the year for Arizona in 1955; he served on Phoenix's Service Employment Redevelopment (SER) Board and was a longtime member of LULAC. In the photograph below is Ray Gano, who received Chicano por La Causas's (CPLC's) Lifetime Achievement Award in 2007. Phoenix LULAC has served in a leadership position for the Mexican American community and is credited with many civil rights changes. Also important to the Phoenix LULAC were Steve and Julia Zozaya, Frank Carrillo, Edward and Ruth Zamora, and Mary Lou Ortega. (Below courtesy Ray Gano.)

Joe Eddie Lopez served on the Maricopa County Board of Supervisors from 1972 to 1976 and later in the state legislature, representing District 22 from 1991 to 1996. Lopez is an example of the fine individuals who represented the Mexican American community of Phoenix. This would include board members, such as Ed Pastor and Mary Rose Wilcox, and legislative representatives, such as Lito Pena, Earl Wilcox, Alfredo Gutierrez, and Jimmy Carreon, who was the first Mexican American state legislator ever elected from Phoenix. (Courtesy Ray Gano.)

Frank "Pipa" Fuentes (left) and Ray Martinez both served as leaders for American Legion Post 41 and were considered strong leaders for the entire Mexican American community. Soon after World War II, both men led Post 41 to get involved in social issues and to force civil rights changes that would eventually contribute to the civil rights movement in the 1960s and 1970s. (Courtesy American Legion Post 41.)

Manuel Garfias, son of the legendary early Phoenix marshal Enrique Garfias, lived in Phoenix for several years but could not make a decent living and eventually moved to the Los Angeles area, where he was successful. He died where he found his success. One can only speculate that if Enrique Garfias had not died prematurely in 1896, he could have been elected to a city council seat, and perhaps Manuel would have followed his father's political career and could have been an early city councilman. (Courtesy Mary Lorona.)

ACROSS AMERICA, PEOPLE ARE DISCOVERING SOMETHING WONDERFUL. *THEIR HERITAGE.*

Arcadia Publishing is the leading local history publisher in the United States. With more than 4,000 titles in print and hundreds of new titles released every year, Arcadia has extensive specialized experience chronicling the history of communities and celebrating America's hidden stories, bringing to life the people, places, and events from the past. To discover the history of other communities across the nation, please visit:

www.arcadiapublishing.com

Customized search tools allow you to find regional history books about the town where you grew up, the cities where your friends and family live, the town where your parents met, or even that retirement spot you've been dreaming about.

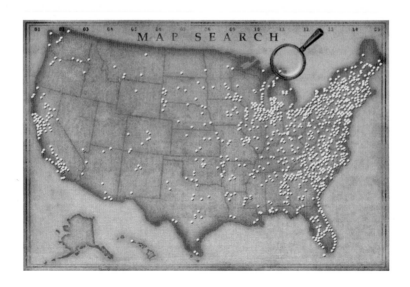